# degas'

# DRAWINGS

DOVER PUBLICATIONS, INC.

NEW YORK

Published in Canada by General Publishing Company, Ltd., 30
Lesmill Road, Don Mills, Toronto, Ontario.
Published in the United Kingdom by Constable and Company,
Ltd., 10 Orange Street, London WC 2.

This Dover edition, first published in 1973, reproduces all the
illustrations in the portfolio *Les Dessins de Degas reproduits en
fac-simile*, edited by Henri Rivière and published by Demotte,
Paris, in the series *Les Dessins des grands artistes français*. This
portfolio, published in a limited edition of 250 copies, consisted
of two series of 50 facsimiles each, dated 1922 and 1923 (the *achevé
d'imprimer* of the text booklet was October 15, 1924). Only eight
drawings are reproduced in color in the present volume. The
captions and the list of plates are based on information in the
original portfolio.

*International Standard Book Number: 0-486-21233-5*
*Library of Congress Catalog Card Number: 73-80952*

Manufactured in the United States of America
Dover Publications, Inc.
180 Varick Street
New York, N.Y. 10014

# LIST OF PLATES
Dimensions are given in millimeters, height before width.

## COLOR
*The color plates appear between plates 22 and 23.*

A. Portrait of a girl. Ca. 1863–65. Oil drawing on ocher paper. 360 × 250. Study for the right-hand figure in the painting *Portrait of the Bellelli Family.*

B. The ballet master. Signed and dated 1875. Oil drawing on greenish ocher paper. 475 × 300. Study for the painting *Ballet Class* in the Louvre. The subject is probably the great choreographer Perrot.

C. Dancer adjusting her slipper. Ca. 1875–78. Oil drawing on pink paper. 380 × 310.

D. Woman undressing. Ca. 1875. Oil on ocher paper transferred to canvas. 610 × 500. Perhaps an early study for the painting *The Rape.*

E. Dancers at the bar. 1877. Oil drawing on Veronese green paper. 465 × 610. Study for the painting.

F. Two studies for a *café-concert* singer. Ca. 1878–80. Charcoal and pastel on gray paper. 575 × 445. Signed.

G. Women ironing. Ca. 1878–82. Charcoal and pastel. 600 × 760. Study for the painting. Signed.

H. Two dancers. Ca. 1884–86. Charcoal and pastel. 600 × 450. Signed.

## BLACK AND WHITE

1. Old Roman beggarwoman. Dated "Rome, 1856." Black crayon on light green paper. 420 × 370.

2. Male nude, foreshortened. Ca. 1856–58. Lead pencil. 230 × 155.

3. Italian landscape. Dated "Tivoli, 1857." Charcoal and chalk on gray-green paper. 300 × 480.

4. Portrait of an elderly lady sewing. Initialed and dated "August 26, 1859, Paris." Charcoal. 290 × 350.

5. Portrait of Mme. Hertel. Ca. 1860. Lead pencil. 248 × 160.

6. Portrait of a girl with a cap. Ca. 1860–61. Lead pencil. 290 × 220.

7. Sleeping child. Ca. 1860–61. Lead pencil. 265 × 190.

8. The painter J.-J. Tissot. Ca. 1861. Charcoal. 310 × 350. Study for a painting.

9. Drapery study. 1861. Lead pencil and gouache on gray paper. 305 × 210. Study for the unfinished painting *Semiramis Building a City*.

10. Drapery study. 1861. Lead pencil. 302 × 224. Another study for *Semiramis*. Signed.

11. Standing girl resting her arm on a table. Ca. 1861–63. Lead pencil. 290 × 185. Study for a painting.

12. Portrait of a woman reclining in an armchair with a magazine on her lap. Ca. 1861–63. Lead pencil. 240 × 450.

13. Landscape in the Département de l'Orne (Normandy). Ca. 1861–64. Pen and sepia wash. 253 × 190. Like No. 14, from the sketchbook of Degas' visit with the Valpinçon family in Le Mesnil-Hubert (Orne).

14. Two views of the village of Exmes (Orne). Ca. 1861–64. Pen and sepia wash. 174 × 770 and 166 × 700.

15. Portrait of Mme. Julie Burtin. 1863. Lead pencil. 360 × 270. Study for the painting *Woman in a Black Dress*.

16. Portrait of Mme. Gobillard-Morisot. Ca. 1863–64. Lead pencil. 310 × 420. Study for a painting.

17. Study of two draped figures. Ca. 1864. Lead pencil. 328 × 215. Perhaps a study for the painting *Jephthah's Daughter*.

18. Studies for a portrait of Manet. Ca. 1864–66. Lead pencil on pink paper. Studies for the etching *Manet Seated, Facing Right*. Signed.

19. Portrait of Manet standing. Ca. 1864–66. Crayon and India ink wash. 352 × 226. Signed.

20. Portrait of Manet. Ca. 1864–66. Crayon. 352 × 229. Study for the etching *Manet Seated, Facing Right*. Signed.

21. Portrait of Mme. Hertel. Signed and dated 1865. Lead pencil. 357 × 232. Study for the painting *Woman with Chrysanthemums*.

22. Portrait of Mlle. Hélène Hertel. Signed and dated 1865. Lead pencil. 250 × 180.

23. Recumbent seminude woman. 1865. Charcoal. 223 × 343. Study for the painting *The Sorrows of the City of Orléans*.

24. Recumbent female nude. 1865. Crayon. 223 × 343. Study for *The Sorrows of the City of Orléans*.

25. Standing female nude. 1865. Lead pencil. 355 × 218. Study for *The Sorrows of the City of Orléans*.

26. Study of an archer. 1865. Charcoal and sanguine (red crayon). 223 × 343. Study for *The Sorrows of the City of Orléans*.

27. Horsewoman. Ca. 1865–67. Lead pencil. 320 × 200.

28. At the racetrack. Ca. 1865–67. Oil drawing on ocher paper. 450 × 310.

29. Two mounted grooms. Ca. 1866–67. Oil drawing on ocher paper. 250 × 340.

30. Young jockey. Ca. 1866–68. Lead pencil. 285 × 230.

31. Monsieur de Broutelles as a jockey. Ca. 1866–68. Black crayon. 340 × 215.

32. Study of an arm. 1868 (?). Charcoal and pastel. 310 × 230. Study for the woman on the right in the painting *Mlle. Fiocre in the Ballet "La Source."*

33. Study of a woman. Ca. 1868–70. Lead pencil on manila paper. 480 × 300. Study

for the unfinished painting *Two Women in Everyday Dress Rehearsing a Duet.*

34. Study of a woman. Ca. 1868–70. Lead pencil on manila paper. 480 × 300. Study for *Two Women Rehearsing a Duet.*

35. Woman sewing. Ca. 1868–70. Lead pencil on blue paper. 380 × 250.

36. Portrait of Mme. Camus. Ca. 1869–70. Charcoal. 350 × 220.

37. At the café. Ca. 1872–74. Thinned oil. 233 × 185.

38. Two dancers leaning on the bar. Ca. 1872–75. Oil drawing on salmon paper. 220 × 270.

39. Three half-length figures of dancers. 1874. Lead pencil on pink paper. 320 × 240. Studies for the painting *Répétition au foyer (Rehearsal in the Green-Room).*

40. Seated dancer, her hand behind her neck. 1874. Oil drawing on dark blue paper. 210 × 260. Study for the cameo painting *Rehearsal of a Ballet on Stage.*

41. Standing dancer with her left arm raised. 1874. Charcoal and chalk on pinkish paper. 450 × 280. Study for the cameo painting *Rehearsal of a Ballet on Stage.*

42. Standing dancer with her arms behind her head. 1874. Wash and gouache on Veronese green paper. 538 × 445. Study for *Rehearsal of a Ballet on Stage.*

43. Standing dancer with her hands behind her back. 1874. Charcoal and chalk on gray-ocher paper. 450 × 300. Study for *Rehearsal of a Ballet on Stage.*

44. Standing dancer, three-quarter view, tying her belt. Ca. 1874. Wash and gouache on manila paper. 545 × 375. Signed.

45. Dancer touching her earring. 1874. Black crayon. 398 × 283.

46. Two standing dancers, one in back view, the other in profile. Ca. 1874–75. Wash and gouache on ocher paper. 300 × 310.

47. Two dancers in back view. Ca. 1874–75. Black crayon and chalk on pinkish paper. 455 × 310. Study for the painting *Ballet Class* in the Metropolitan Museum of Art.

48. Study of a head and sketch of a seated dancer stooping. Ca. 1874–75. Charcoal and pastel on pinkish paper. 460 × 300.

49. Dancer scratching her back. Ca. 1874–75. Black crayon on grayish pink paper. 440 × 294. Study for the painting *Ballet Class* in the Louvre.

50. Standing man with a derby and an umbrella. Ca. 1875. Oil on ocher paper. 330 × 200.

51. Dancer leaning forward. Ca. 1875. Black crayon and chalk on gray paper. 440 × 300. Study for the *Ballet Class* in the Metropolitan Museum of Art.

52. Half-dressed young woman. Ca. 1875. Thinned oil on canvas. 340 × 200. Study for the painting first called *The Rape,* then *Interior Scene.*

53. Sketches of dancers. Ca. 1875. Sepia wash with added blue ink on letter paper. 250 × 200.

54. Half-length figure of a dancer reading a letter. 1875. Charcoal. 400 × 290. Study for the painting *Ballet Class* in the Louvre.

55. Three ladies in street dress. Ca. 1875–76. Black crayon, charcoal, and pastel highlights. 440 × 630. Inscription (in crayon): "Portraits in a frieze for the decoration of an apartment."

56. Standing dancer fluffing up her dress. Ca. 1875–76. Black crayon on pinkish paper. 475 × 370.

57. Woman holding a parasol. Ca. 1875–76. Thinned oil on canvas. 750 × 850.

58. Jockey on a galloping horse. Ca. 1875–76. Charcoal on manila paper. 315 × 225.

59. Dancer leaning forward as a dresser stitches her dress. Ca. 1875–76. Charcoal and chalk. 340 × 290. Study for the painting *Ballet Class* in the Jacques Blanche collection.

60. Three studies for a dancer's head. Ca. 1876–78. Charcoal and pastel. 180 × 567.

61. Two dancers resting. Ca. 1876–80. Charcoal and chalk. 300 × 460. Color indications above.

62. Three sketches of a nude young dancer. Ca. 1876–80. Charcoal and chalk on gray-green paper. 480 × 630. Studies for the wax statuette *Fourteen-Year-Old Dancer*.

63. Four sketches of a young dancer. Ca. 1876–80. Charcoal. 480 × 300. Studies for the statuette *Fourteen-Year-Old Dancer*.

64. Dancer at the bar. 1877. Black crayon. 305 × 194. Study for the painting.

65. The prostitute Elisa. Ca. 1877–78. Lead pencil on gray paper. 335 × 250.

66. Stooping dancer, seen from behind. Ca. 1877–78. Oil drawing on paper that was pink but has faded. 320 × 280. Signed and dedicated to Mathey.

67. Mélina Darde. Signed and dated December 1878. Black crayon. 305 × 230. Inscribed below: "Mélina Darde, 15 years old, dancer at the Gaîté." Color indications above.

68. Seated dancer pulling up her tights. Ca. 1878–80. Black crayon. 320 × 225.

69. Standing dancer in profile. Ca. 1878–80. Pastel on ocher paper. 600 × 450.

70. *Café-concert* singer. Ca. 1878–80. Charcoal on gray paper. 465 × 300. Study for a painting and a pastel.

71. Portrait of Mlle. Hortense Valpinçon (later Mme. Jacques Fourchy). Ca. 1878–80. Lead pencil and pastel. 230 × 160.

72. Woman tying the ribbons of her hat. Ca. 1878–82. Charcoal and pastel. 480 × 310. Study for the pastel *At The Milliner's*.

73. Laundress ironing clothes. Ca. 1878–82. Oil on canvas. 460 × 560. Signed.

74. Miss Lala at the Fernando Circus. Dated January 25, 1879. Charcoal and pastel on manila paper. 470 × 320. Study for the painting.

75. Portrait of Duranty. 1879. Charcoal and chalk on gray-blue paper. 300 × 460.

76. Portrait of the engraver Diégo Martelli. 1879. Charcoal and chalk on reddish brown paper. 420 × 300.

77. Head of a woman. Ca. 1879–80. Lead pencil. 165 × 240.

78. Standing dancer with her right leg raised. Ca. 1879–82. Charcoal and chalk on gray-green paper. 465 × 610.

79. Woman drying herself after a bath. Ca. 1880–82. Thinned oil on canvas. 1051 × 2015. Preparatory drawing for a painting.

80. Dancer standing on one leg with one arm raised. Ca. 1882–85. Pastel on ocher paper. 305 × 225.

81. Woman washing. Ca. 1883. Charcoal and pastel. 620 × 470.

82. Three dancers. Ca. 1885–88. Charcoal and pastel on gray paper. 450 × 595. Signed.

83. Three nude women under trees after bathing. Ca. 1885–90. Charcoal and sanguine with touches of pastel on canvas. 1012 × 1044.

84. Woman drying herself after a bath. Ca. 1885–90. Charcoal on tracing paper. 410 × 280.

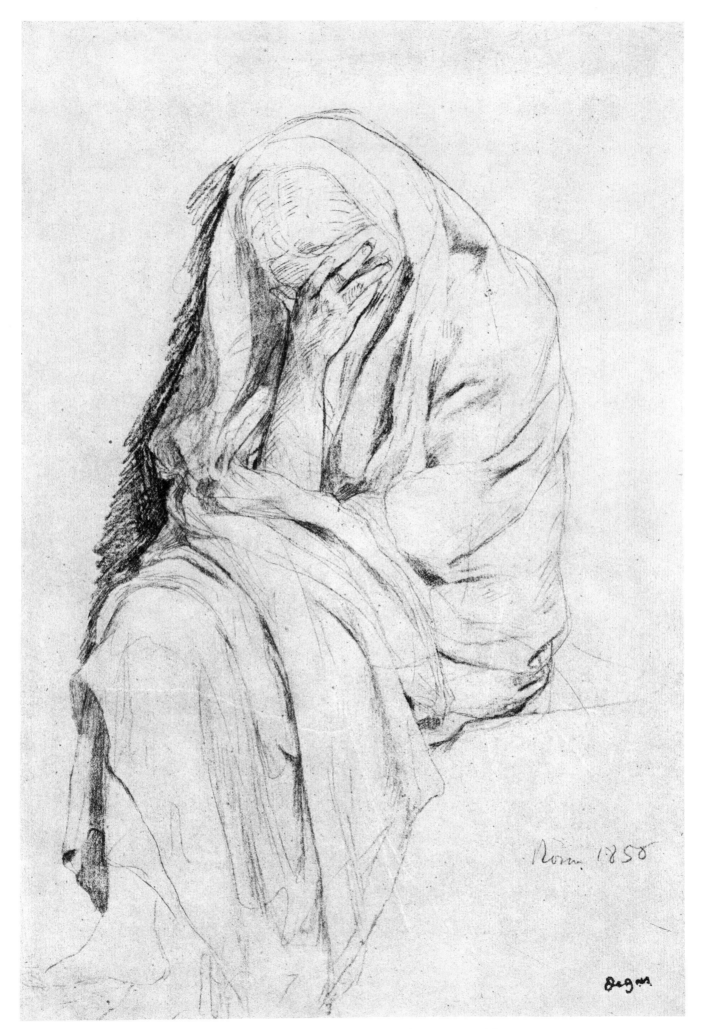

1. Old Roman beggarwoman. Dated "Rome, 1856."

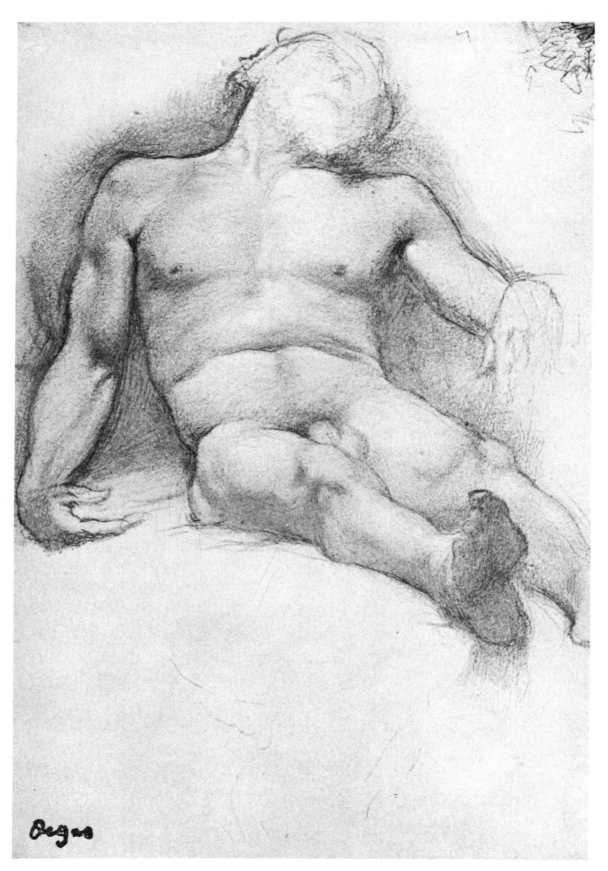

2. Male nude, foreshortened. Ca. 1856–58.

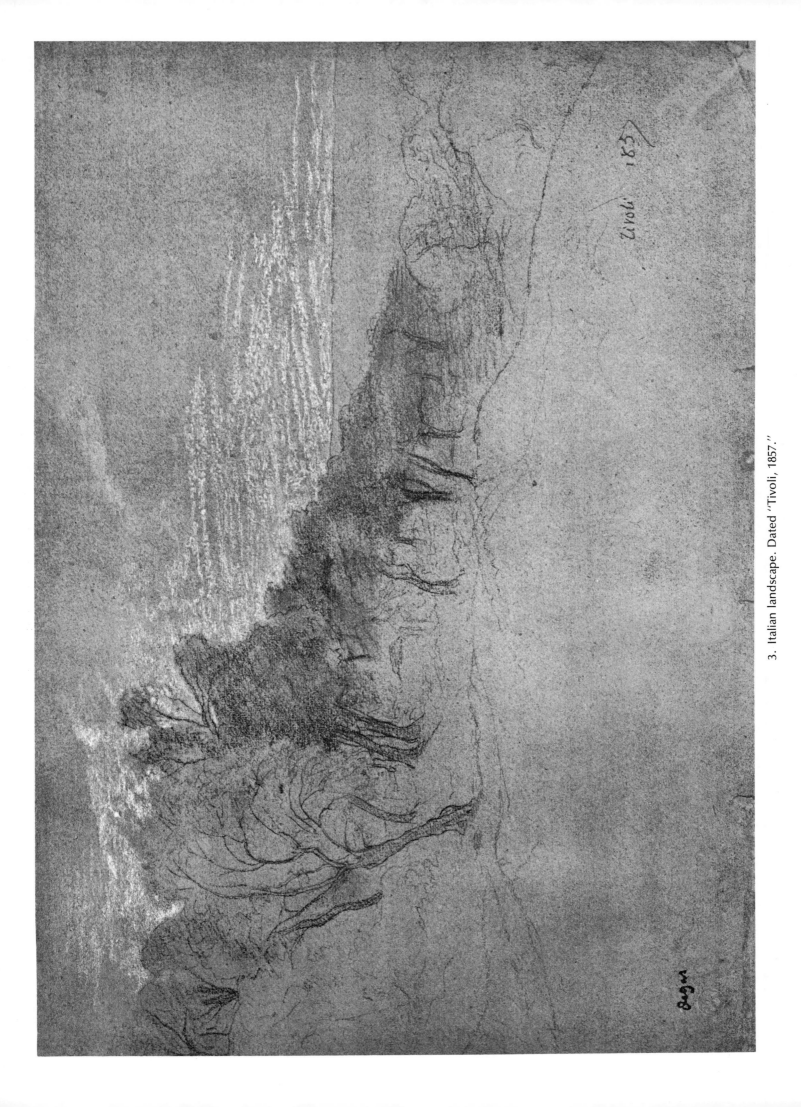

3. Italian landscape. Dated "Tivoli, 1857."

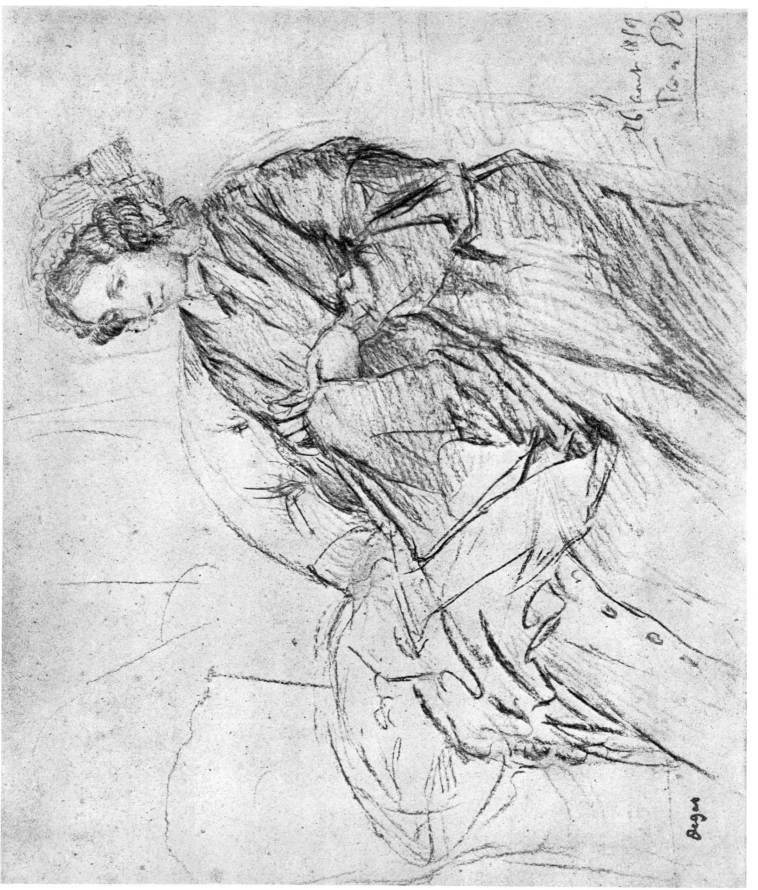

4. Portrait of an elderly lady sewing. Initialed and dated "August 26, 1859, Paris."

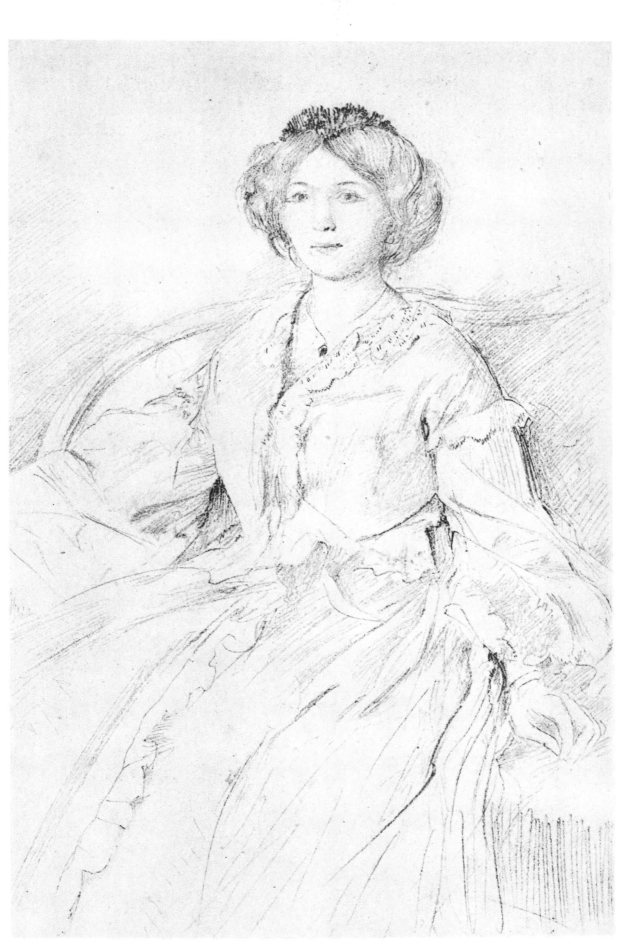

5. Portrait of Mme. Hertel. Ca. 1860.

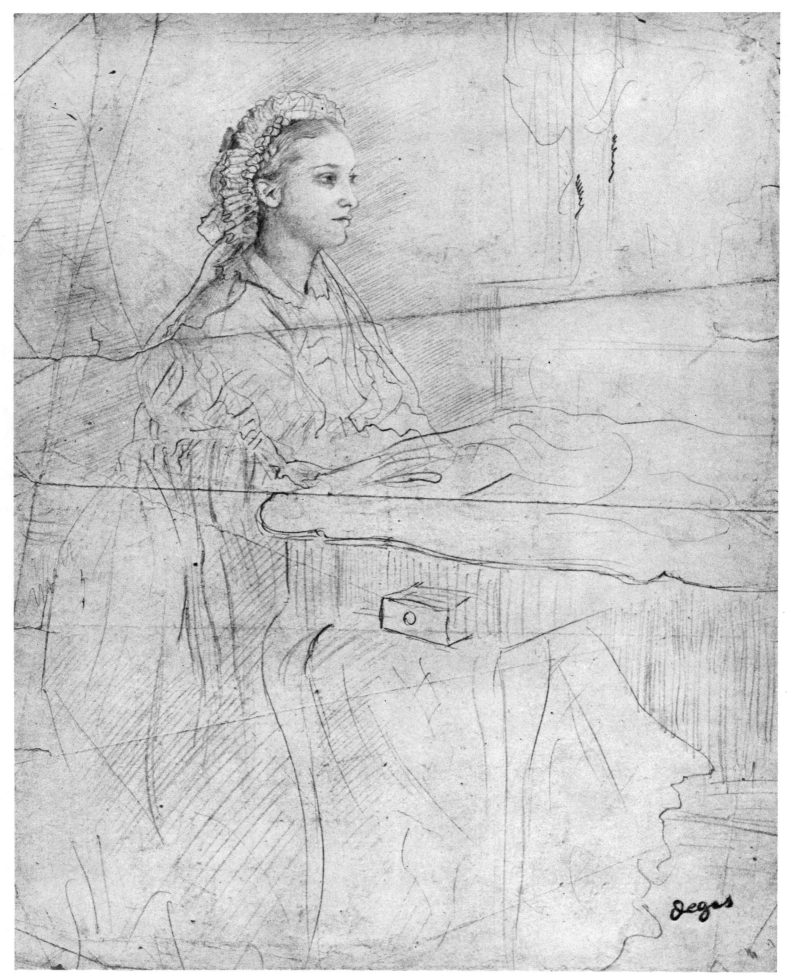

6. Portrait of a girl with a cap. Ca. 1860–61.

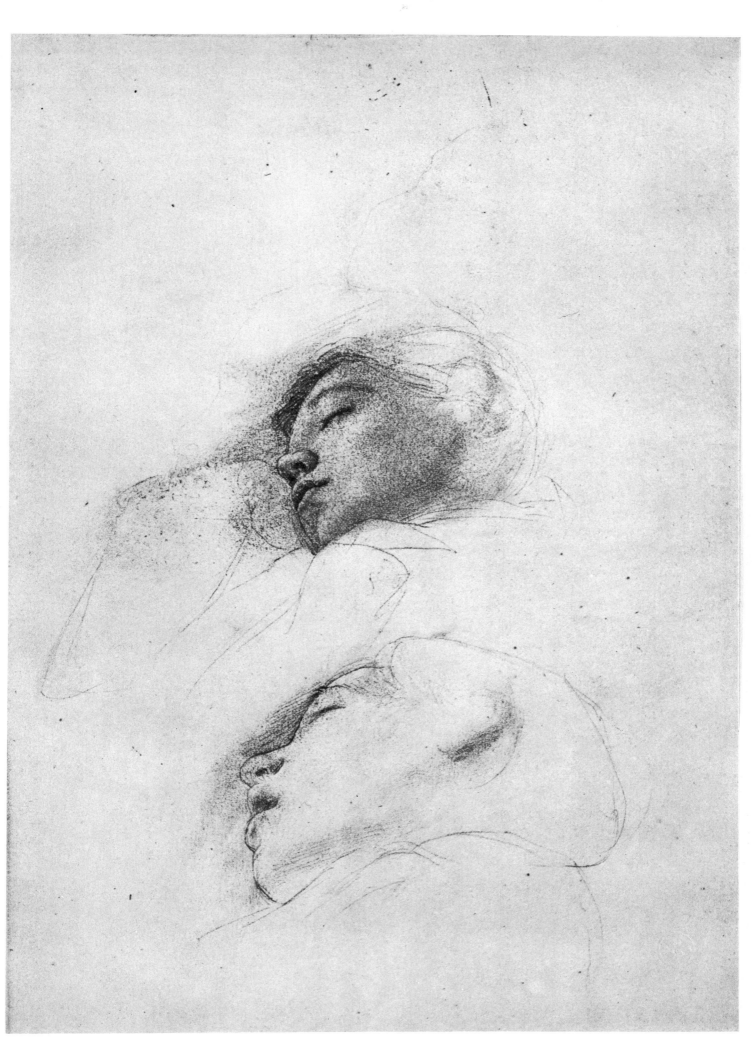

7. Sleeping child. Ca. 1860–61.

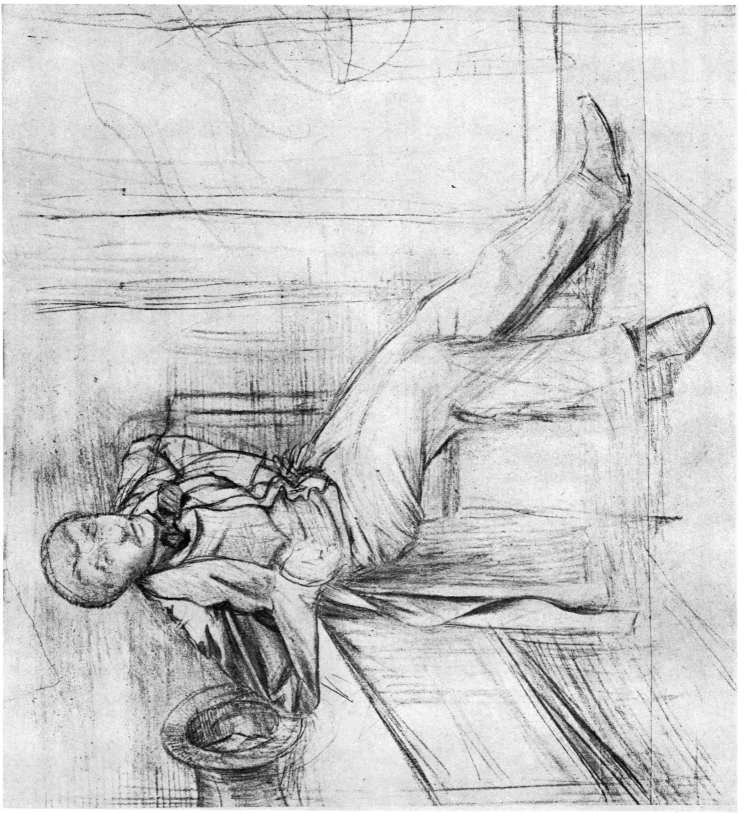

8. The painter J.-J. Tissot. Ca. 1861.

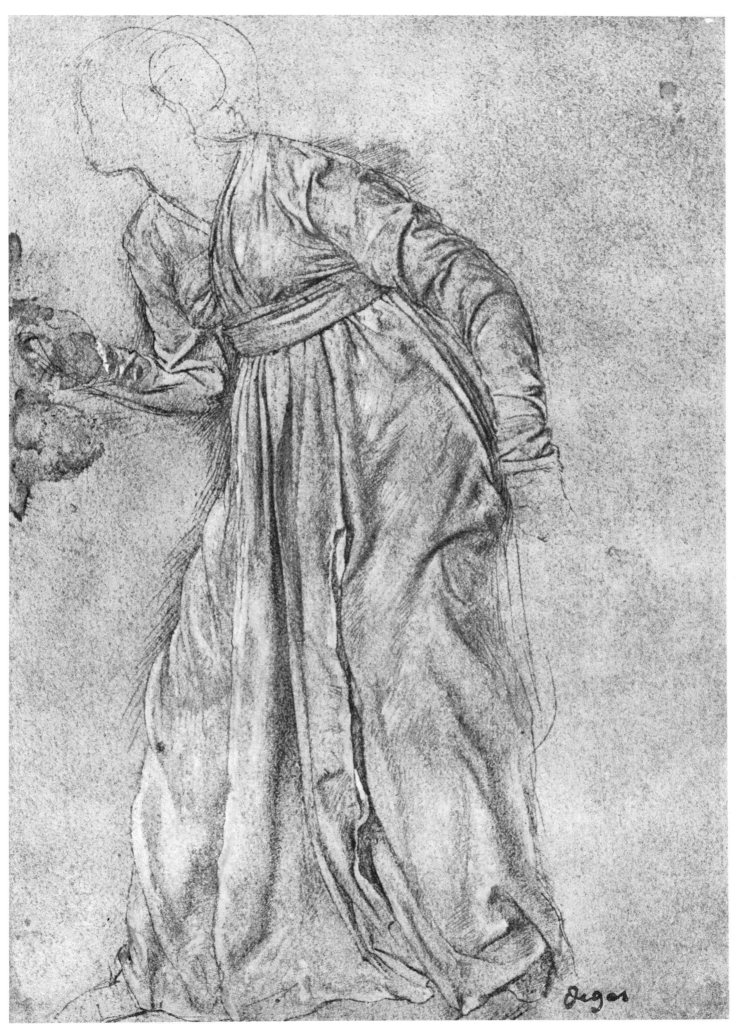

9. Drapery study. 1861.

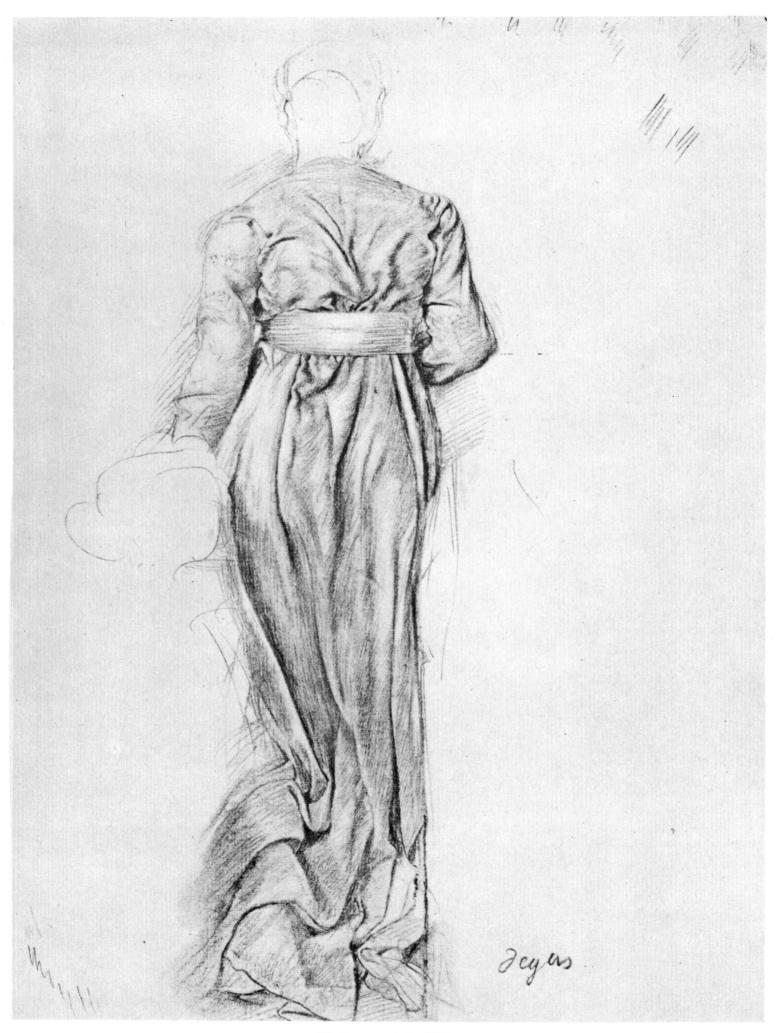

10. Drapery study. 1861.

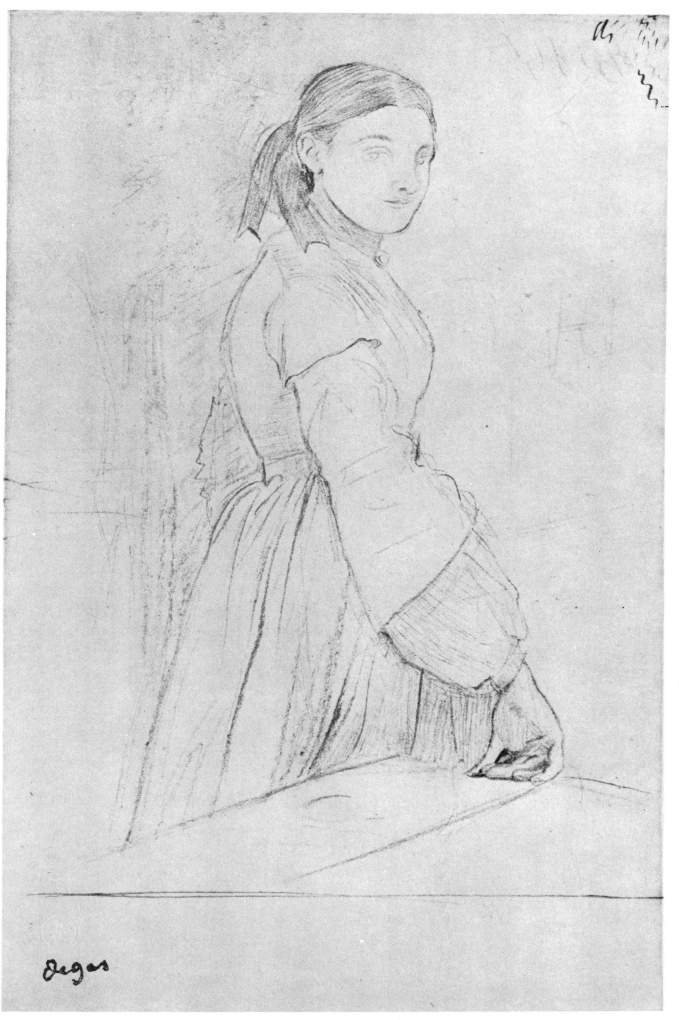

Degas

11. Standing girl resting her arm on a table. Ca. 1861–63.

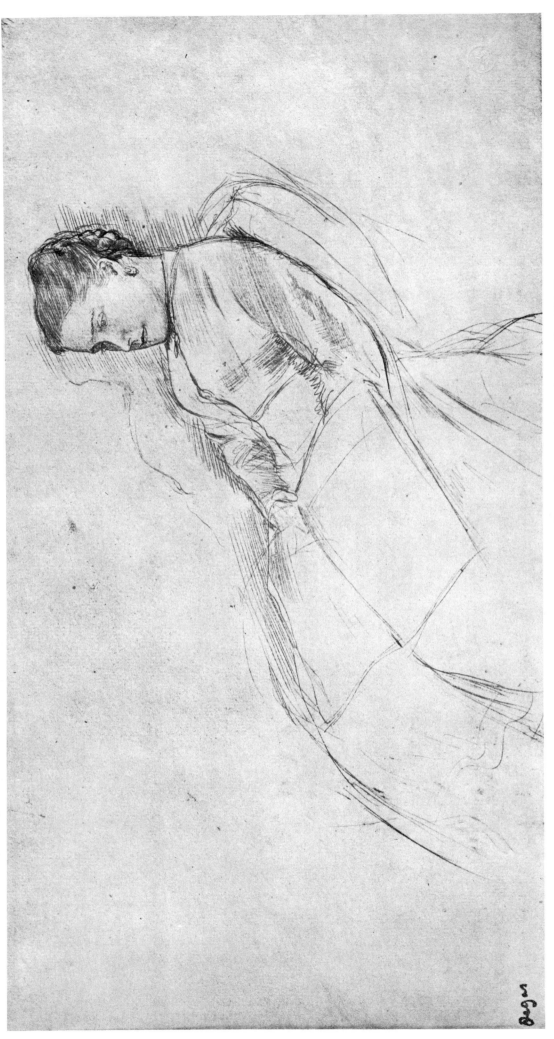

12. Portrait of a woman reclining in an armchair with a magazine on her lap. Ca. 1861–63.

13. Landscape in the Département de l'Orne (Normandy). Ca. 1861–64.

14. Two views of the village of Exmes (Orne). Ca. 1861–64.

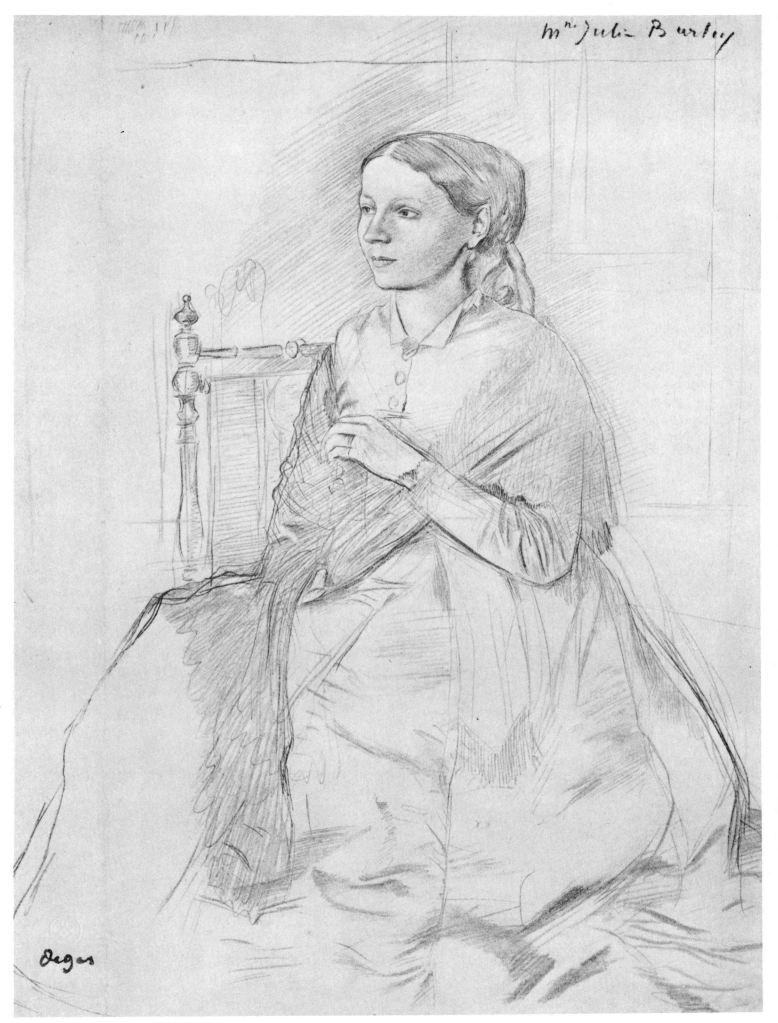

15. Portrait of Mme. Julie Burtin. 1863.

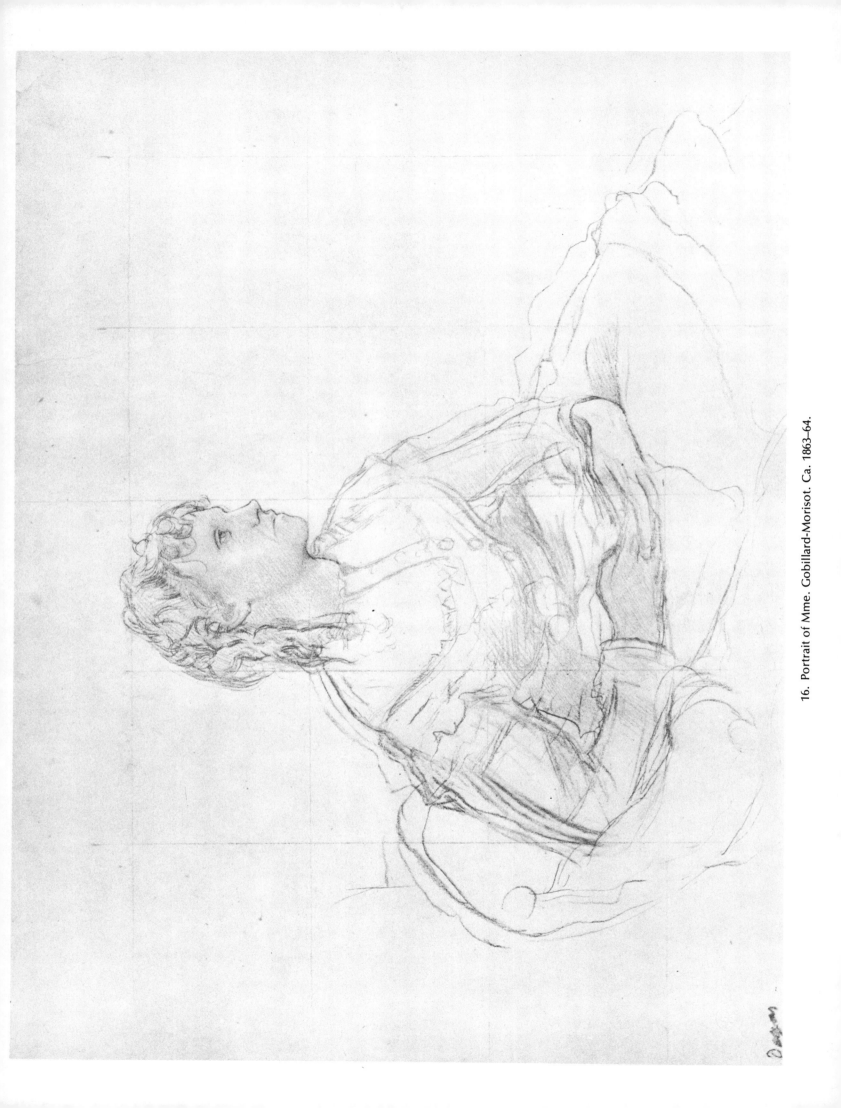

16. Portrait of Mme. Gobillard-Morisot. Ca. 1863-64.

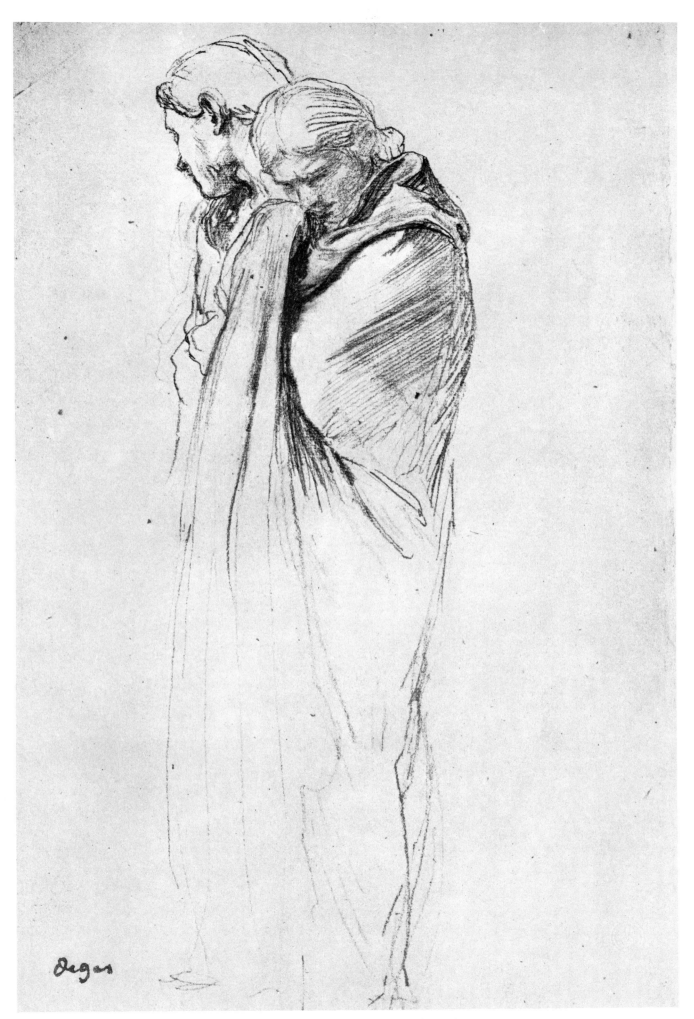

17. Study of two draped figures. Ca. 1864.

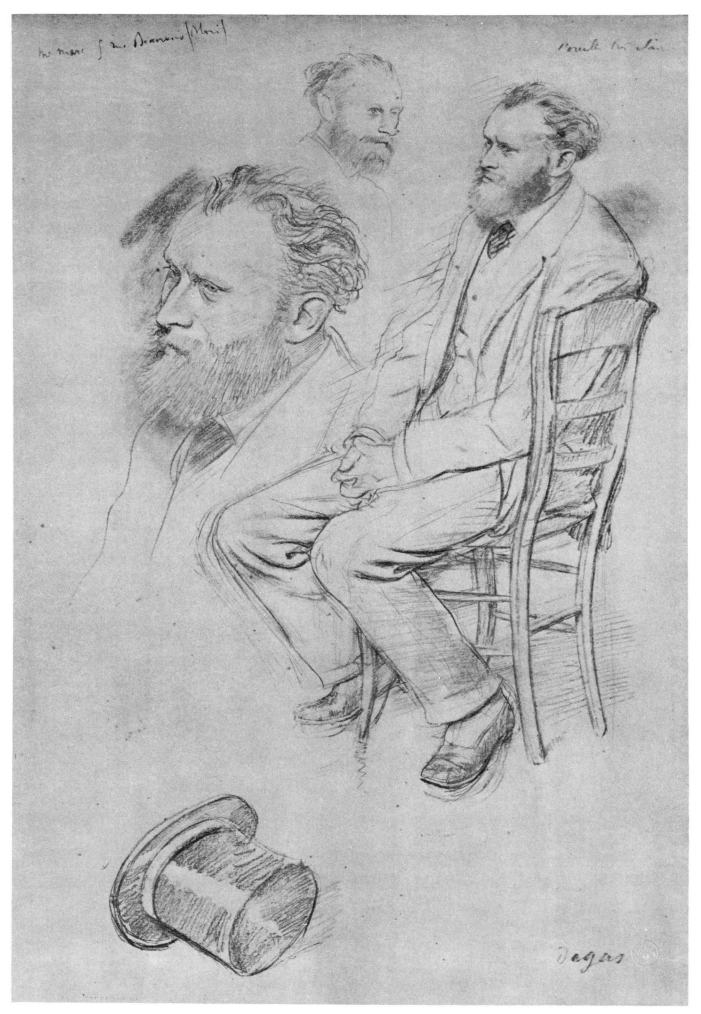

18. Studies for a portrait of Manet. Ca. 1864–66.

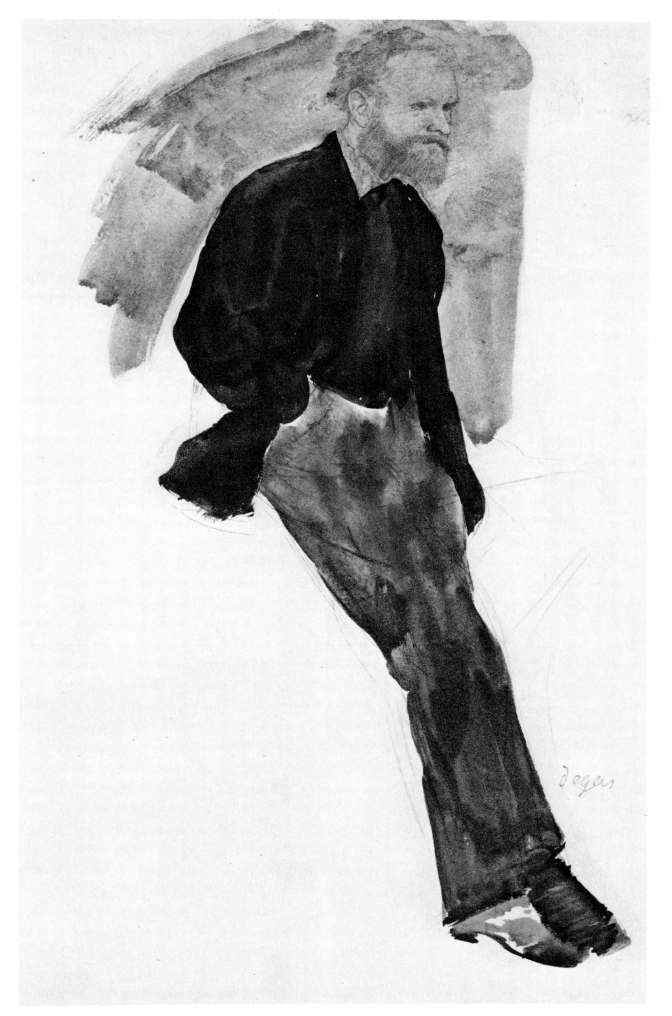

19. Portrait of Manet standing. Ca. 1864–66.

20.  Portrait of Manet. Ca. 1864–66.

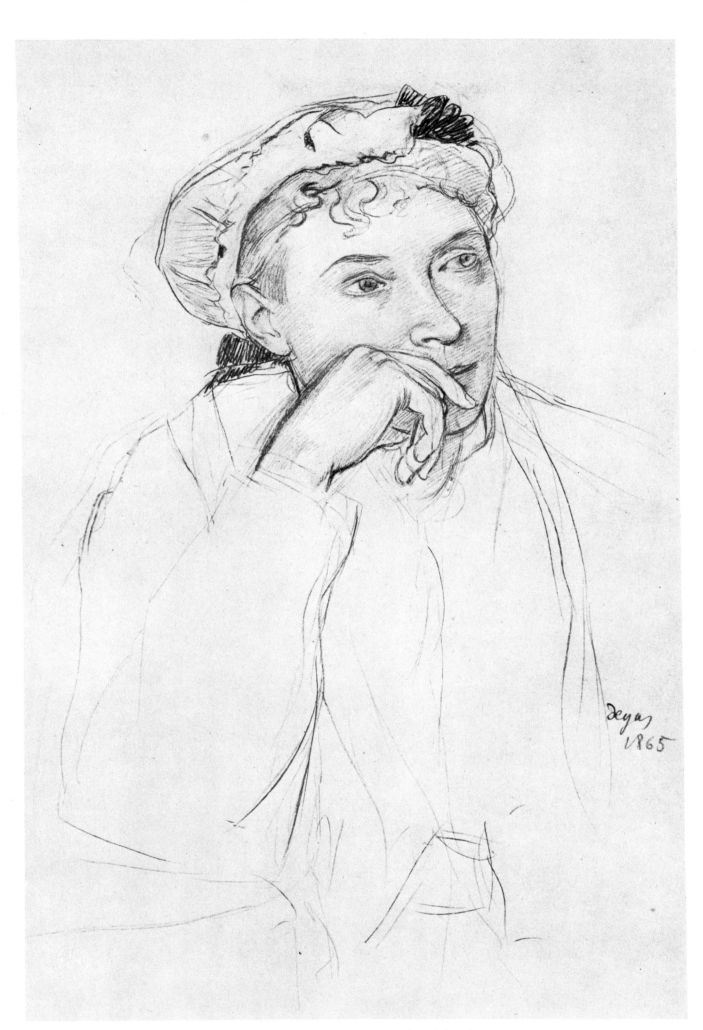

21. Portrait of Mme. Hertel. Signed and dated 1865.

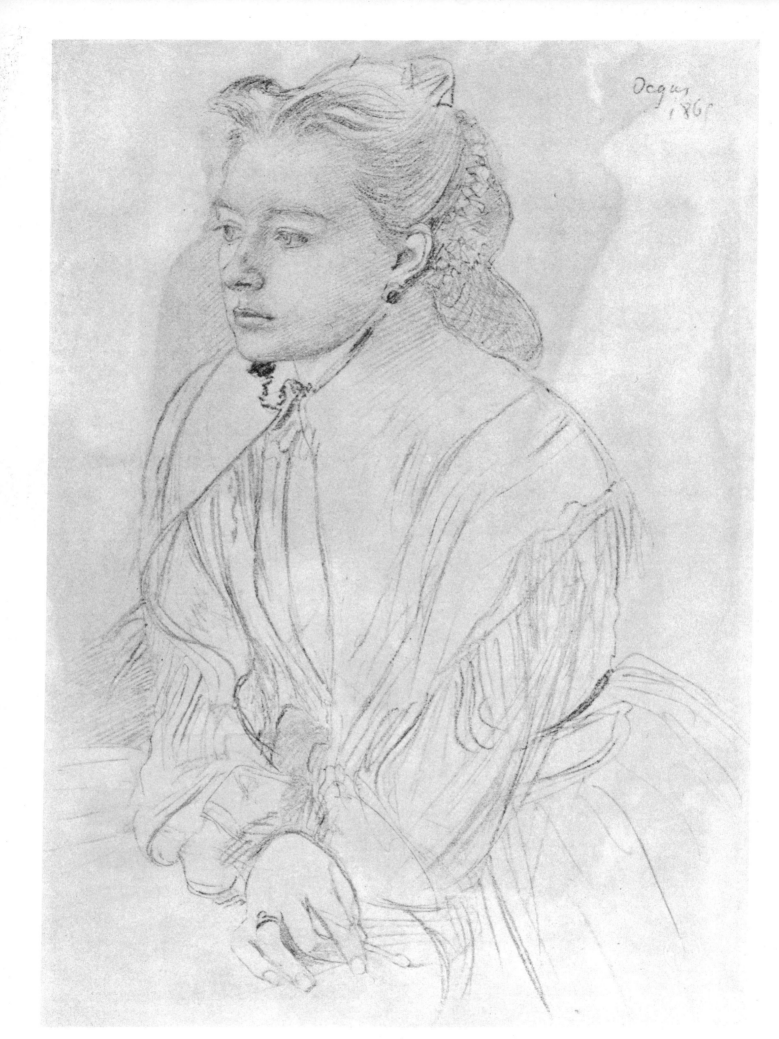

22. Portrait of Mlle. Hélène Hertel. Signed and dated 1865.

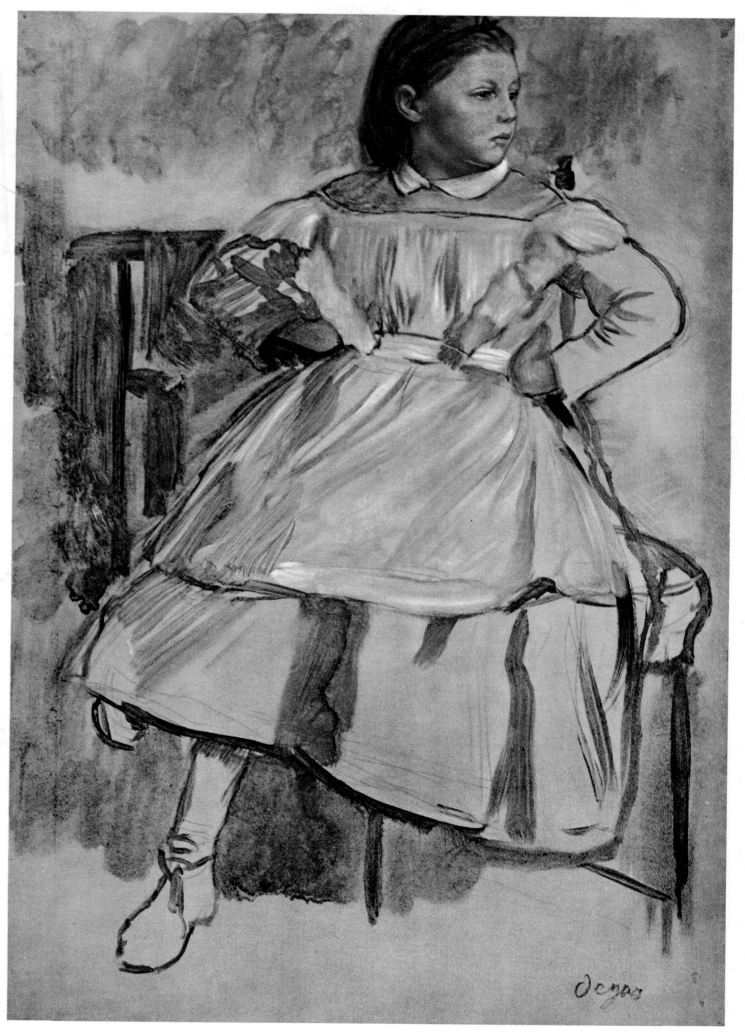

A. Portrait of a girl. Ca. 1863–65.

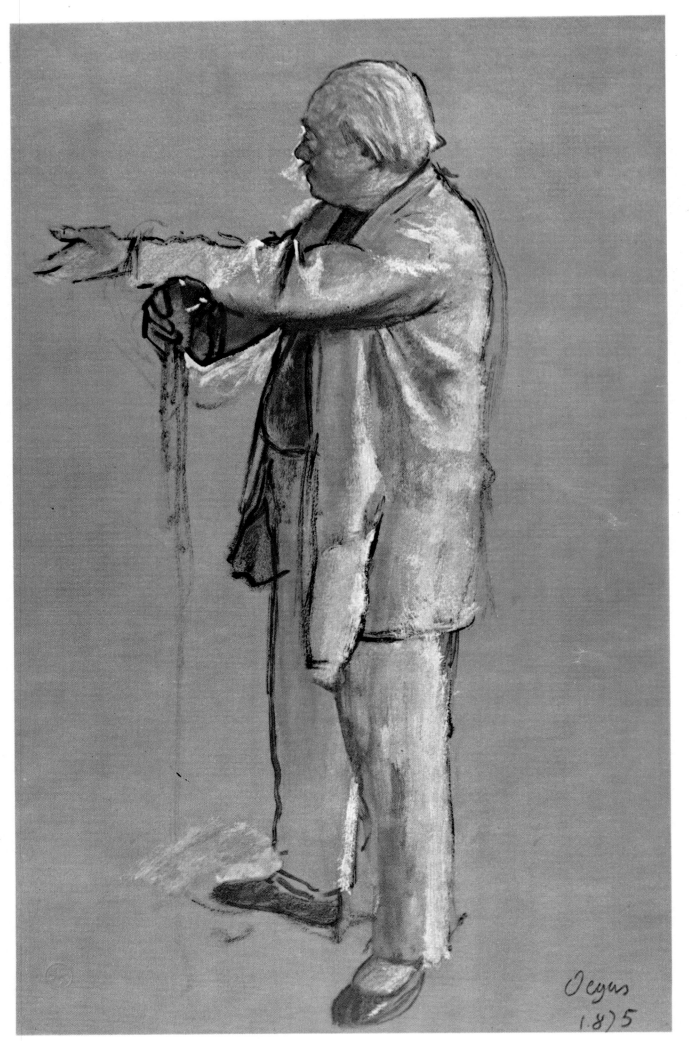

B. The ballet master. Signed and dated 1875.

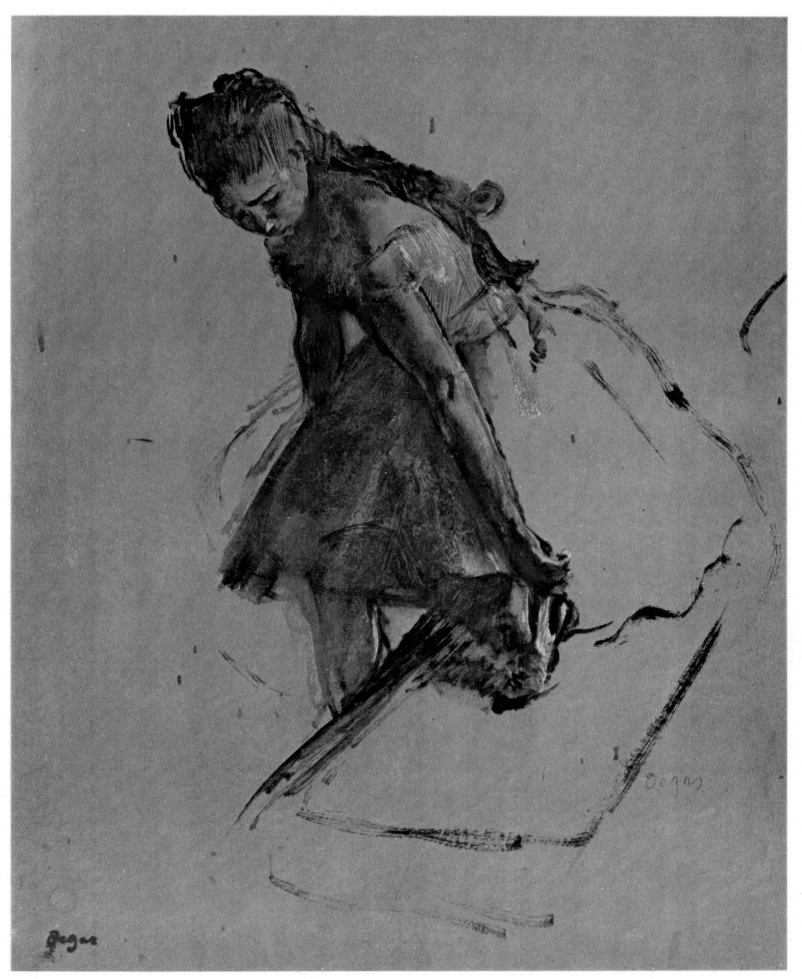

C. Dancer adjusting her slipper. Ca. 1875–78.

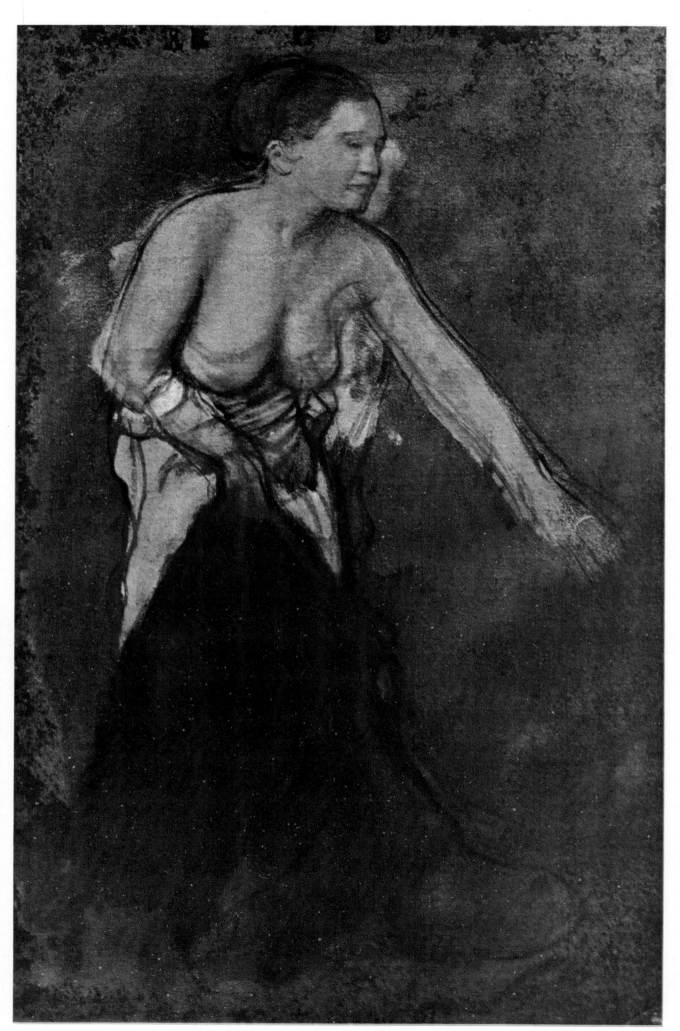

D. Woman undressing. Ca. 1875.

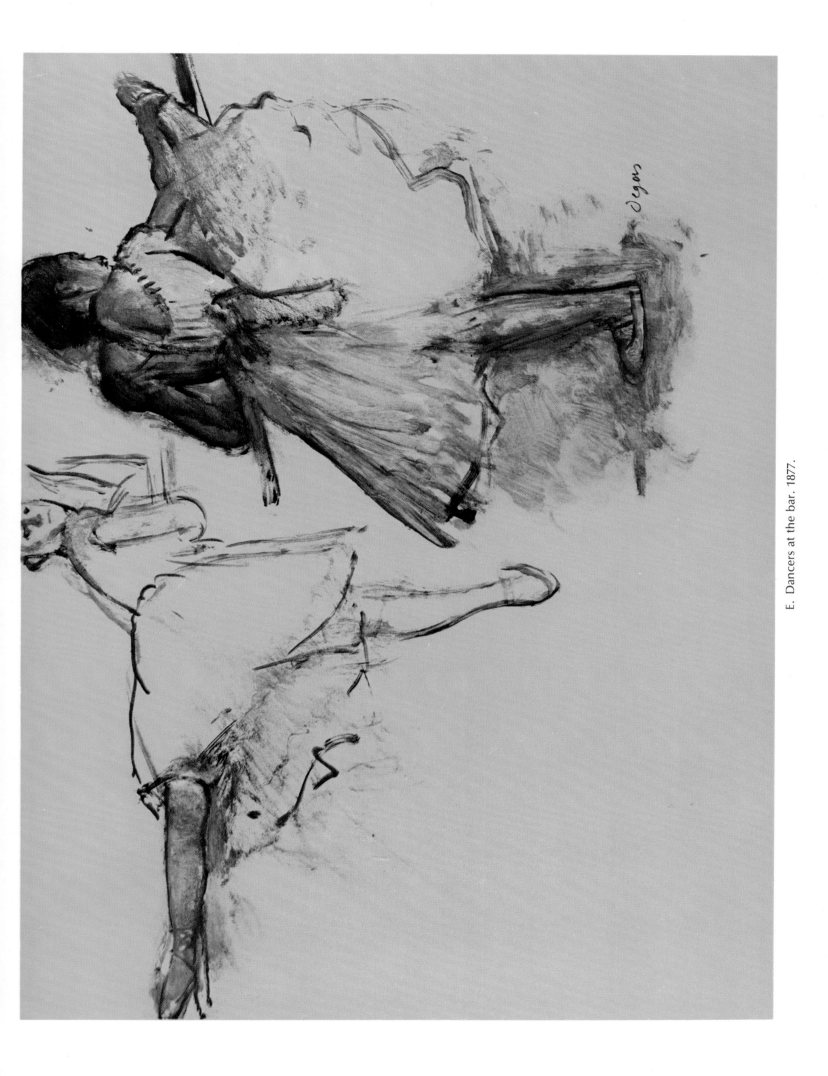

E. Dancers at the bar. 1877.

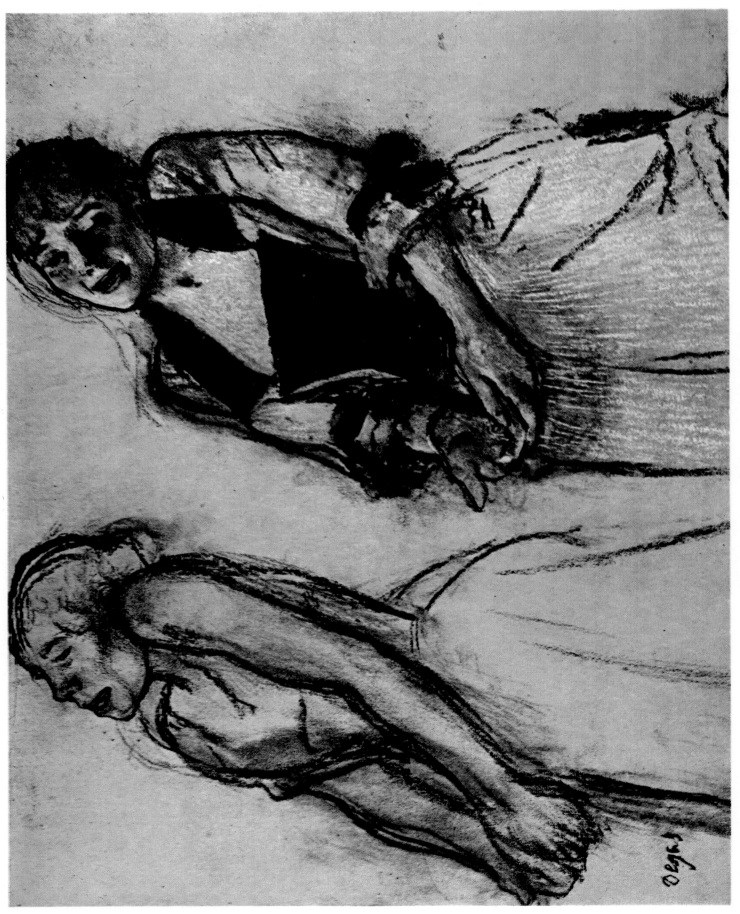

F. Two studies for a *café-concert* singer. Ca. 1878–80.

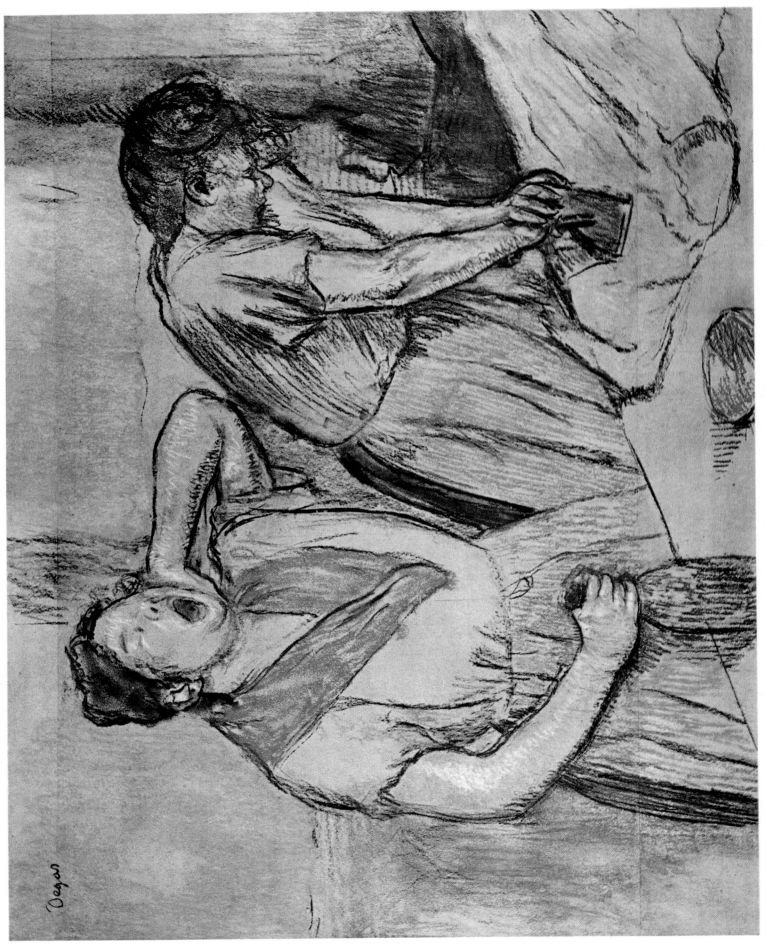

G. Women ironing. Ca. 1878–82.

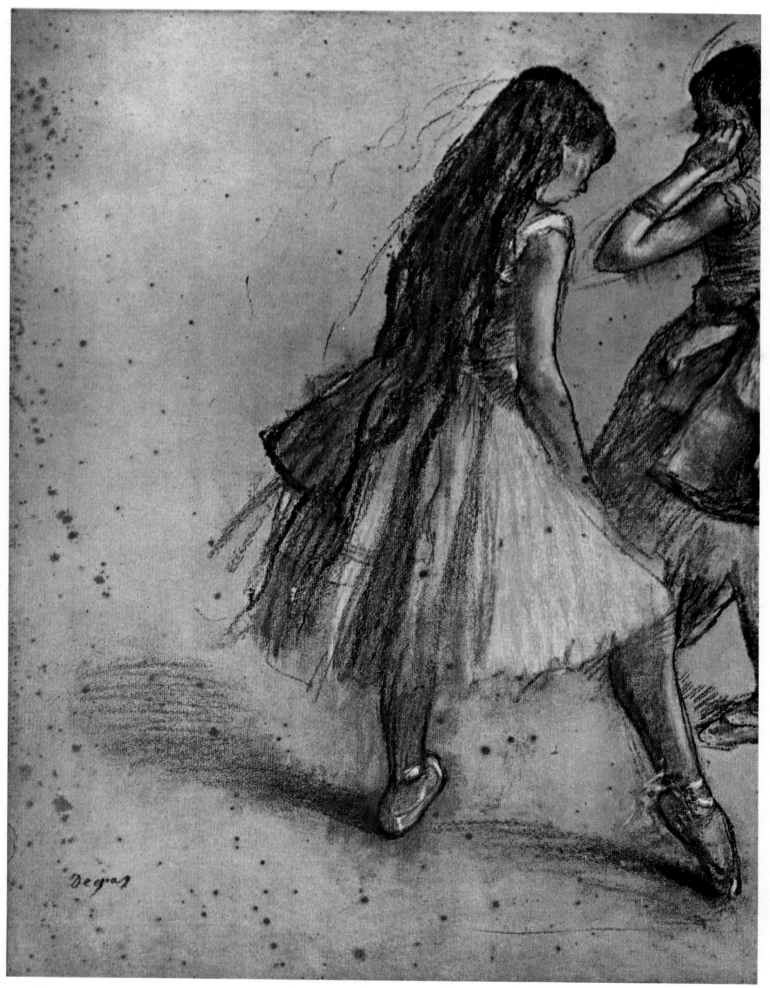

H. Two dancers. Ca. 1884–86.

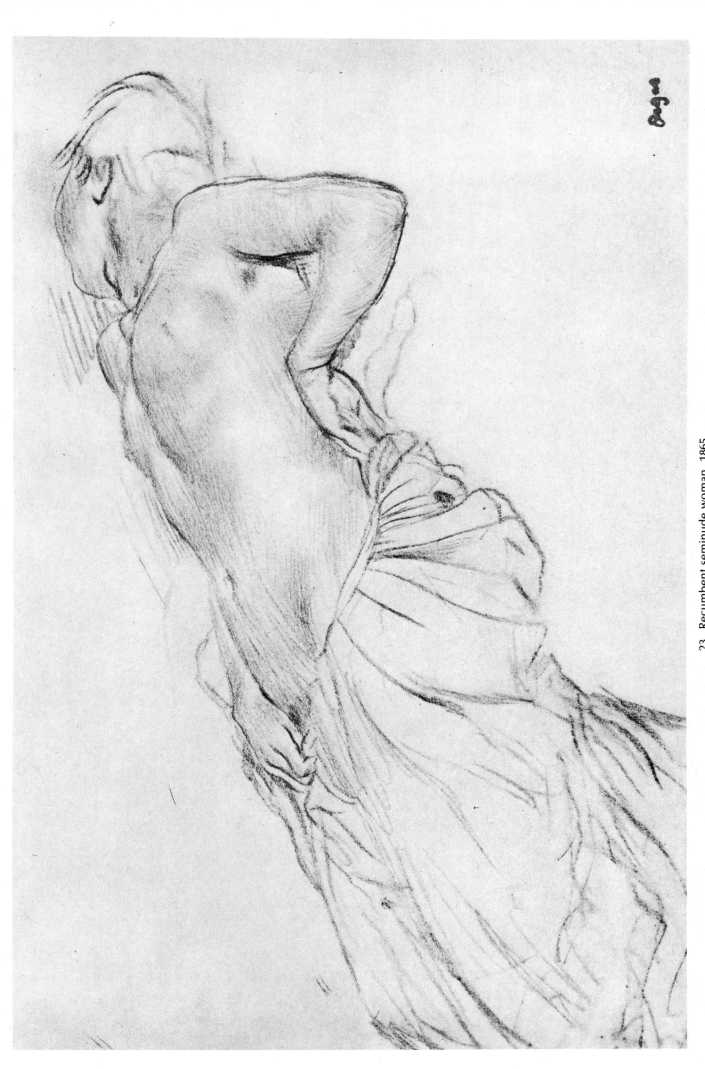

23.  Recumbent seminude woman. 1865.

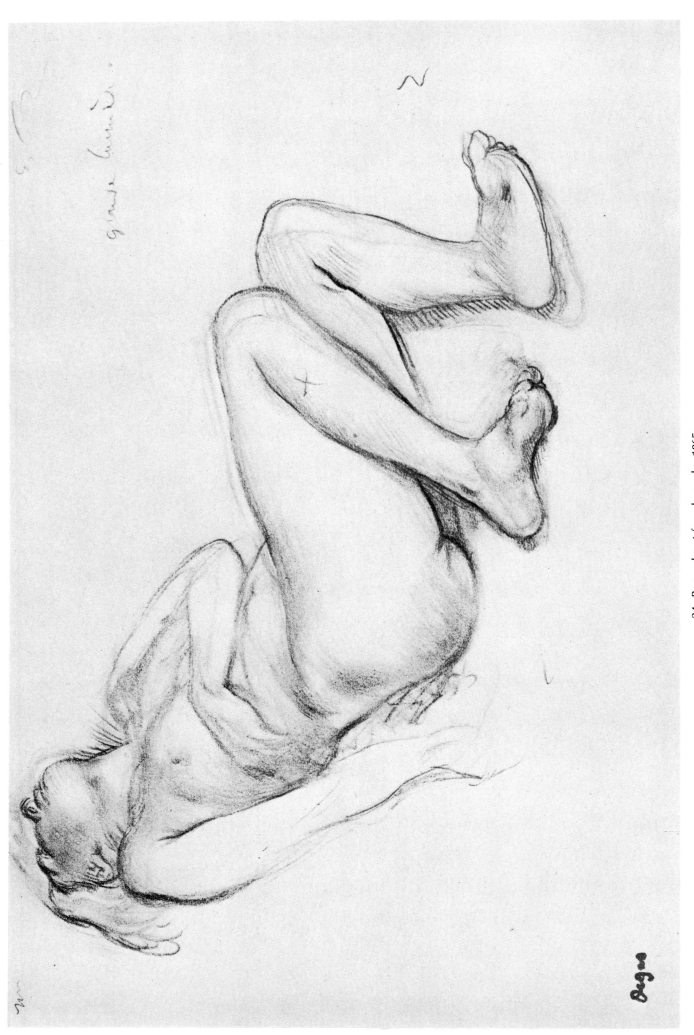

24. Recumbent female nude. 1865.

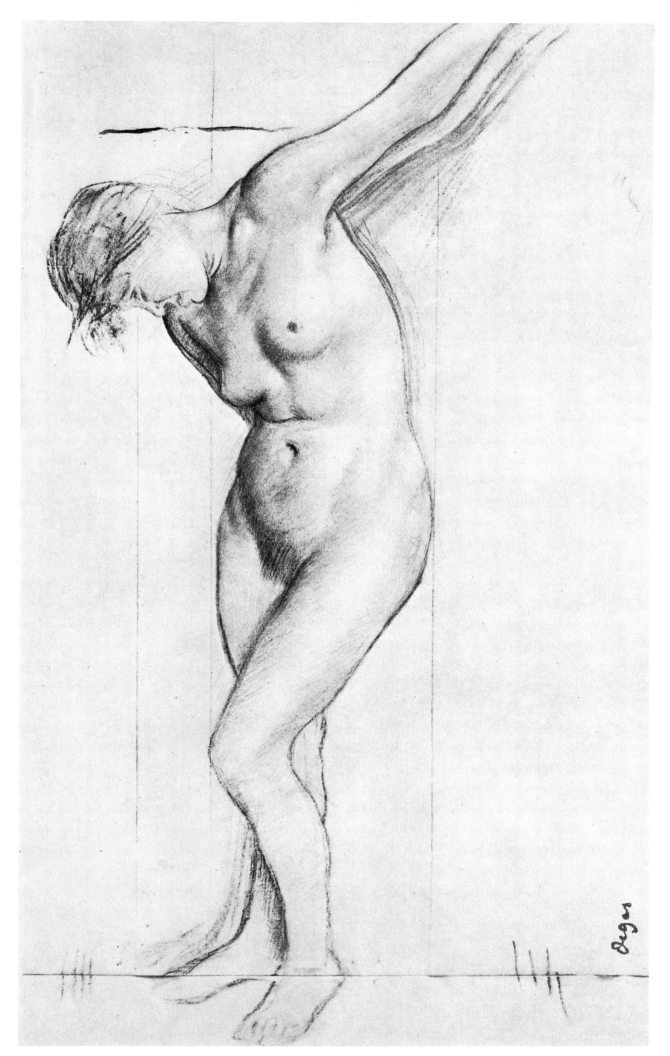

25.  Standing female nude. 1865.

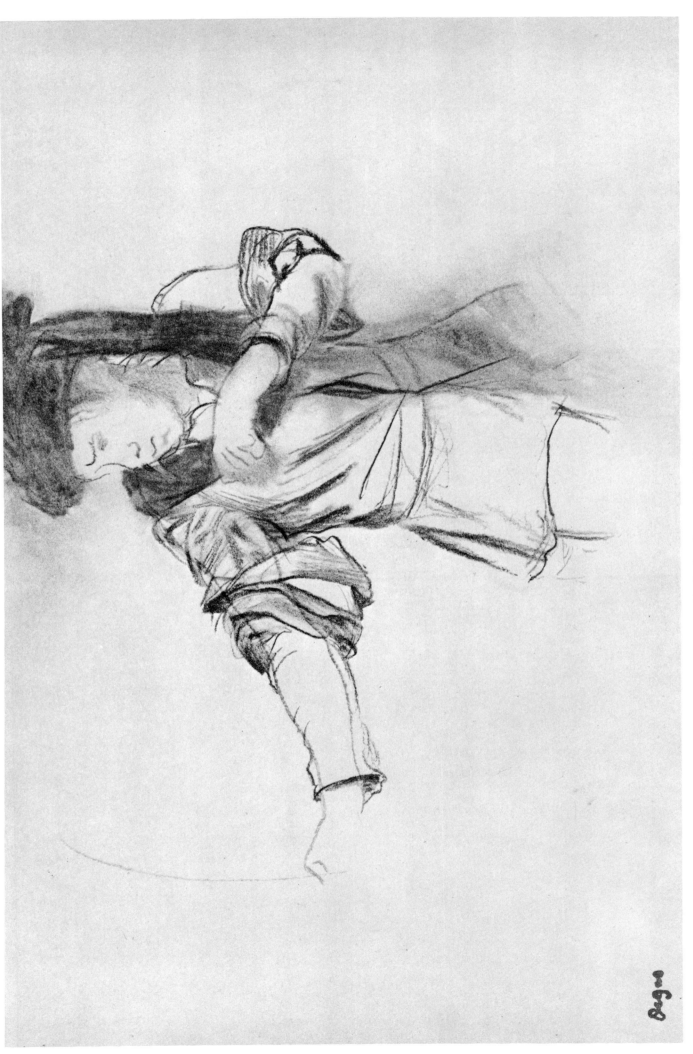

26. Study of an archer. 1865.

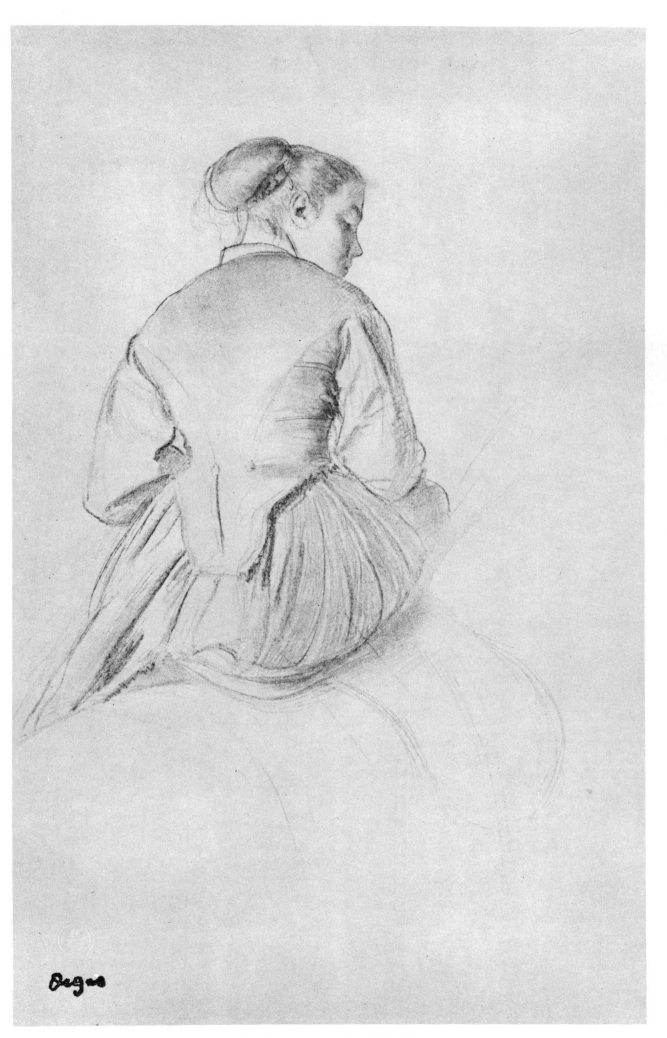

27. Horsewoman. Ca. 1865–67.

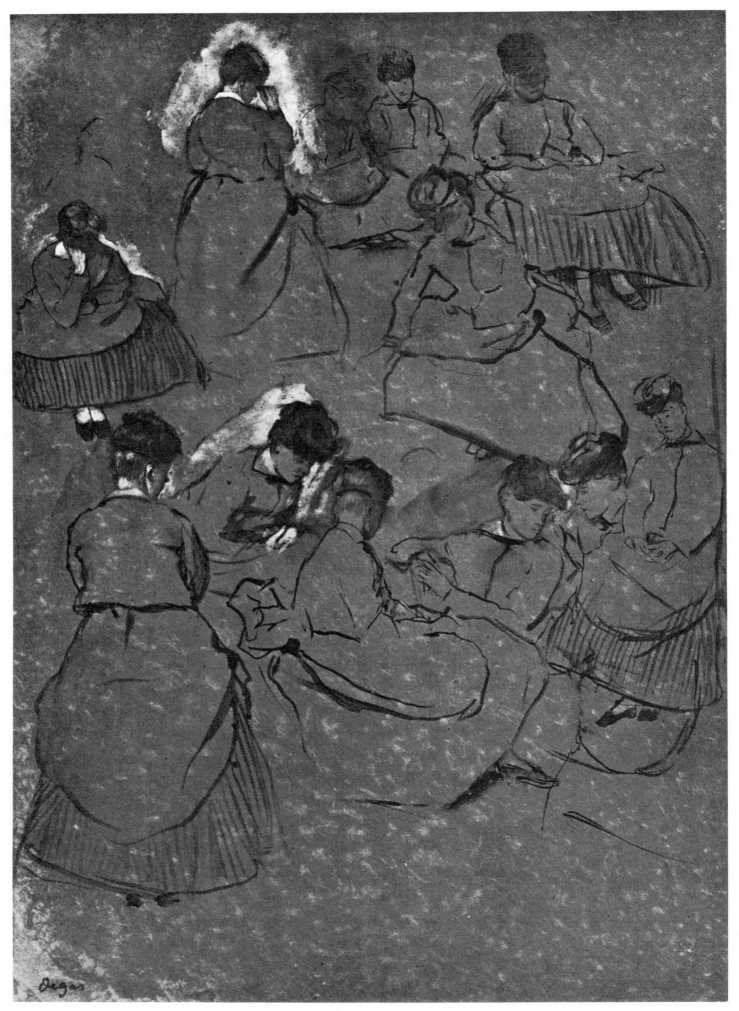

28. At the racetrack. Ca. 1865–67.

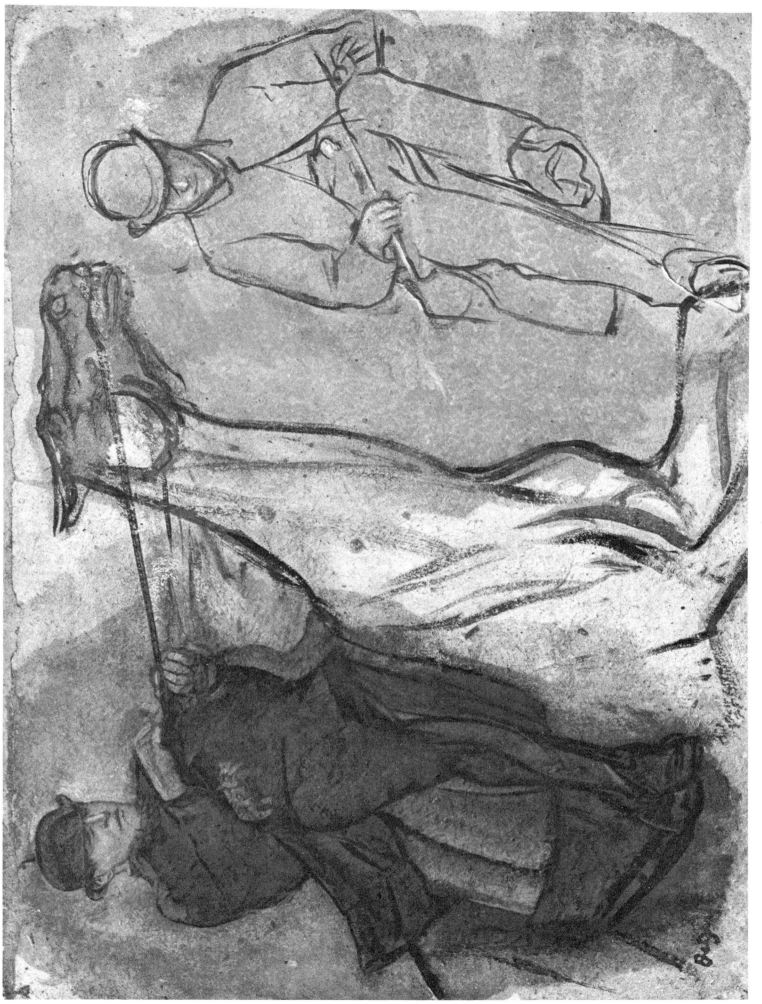

29. Two mounted grooms. Ca. 1866–67.

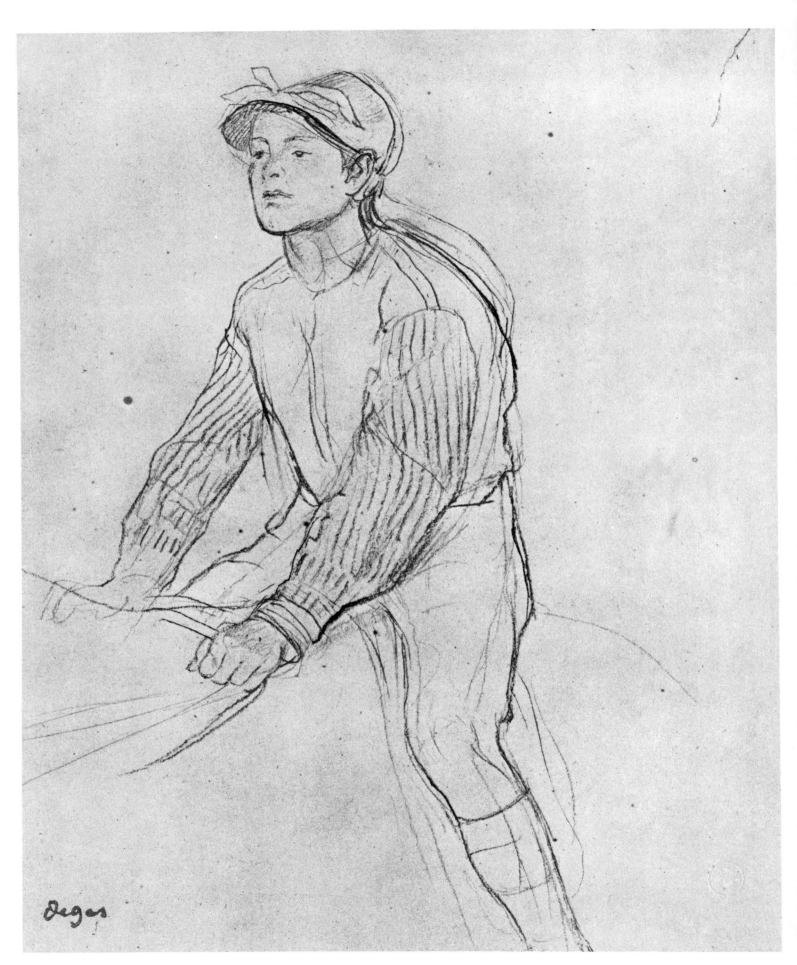

30. Young jockey. Ca. 1866–68.

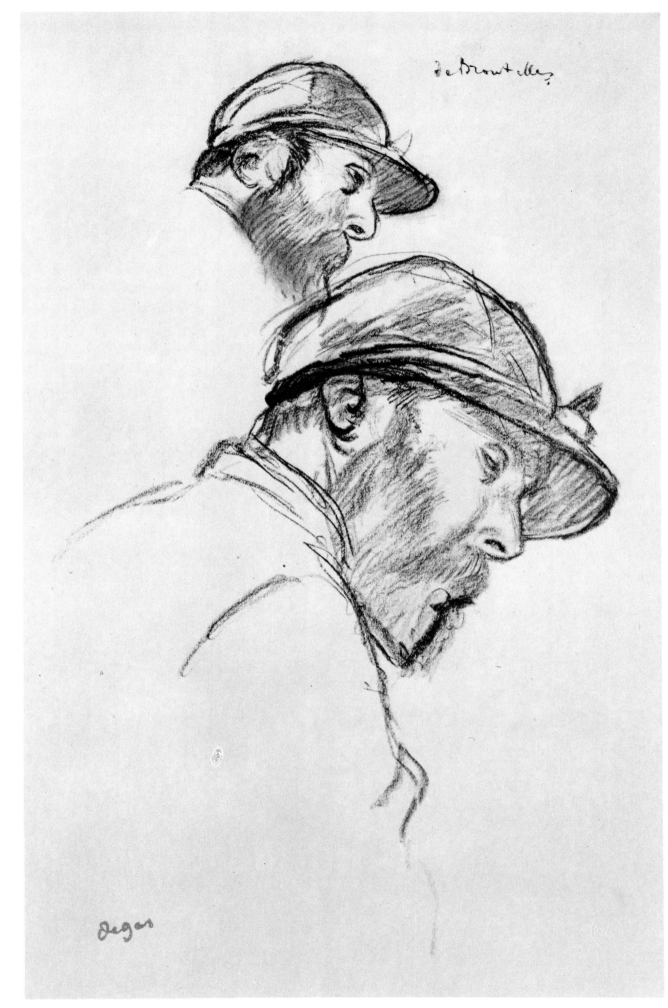

31.  Monsieur de Broutelles as a jockey. Ca. 1866–68.

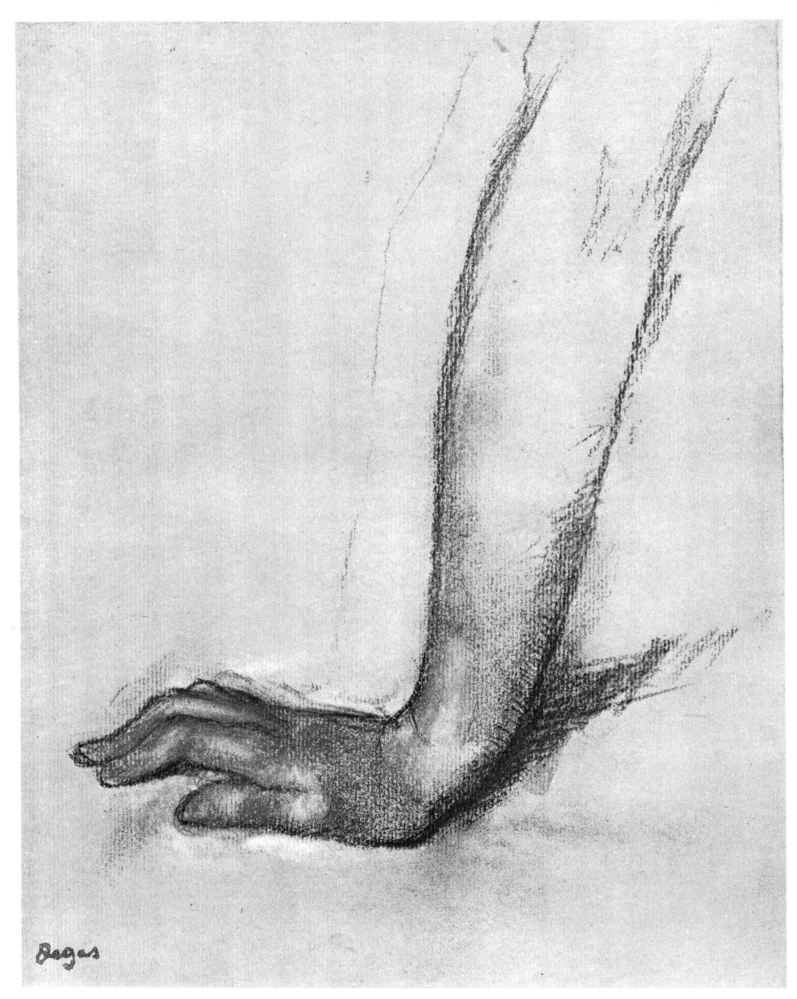

32. Study of an arm. 1868 (?).

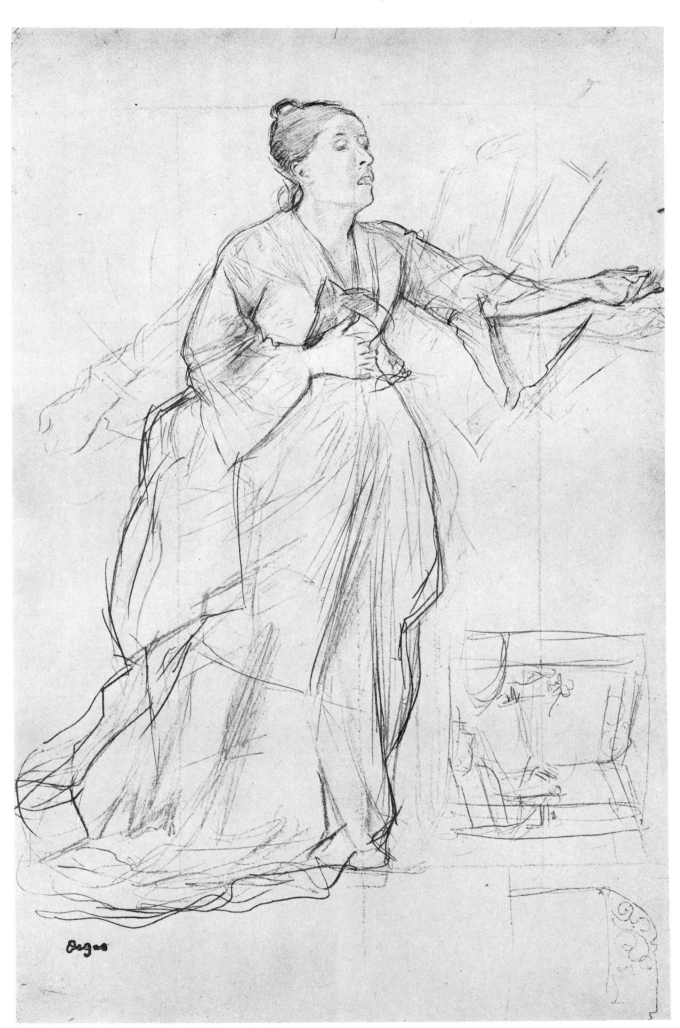

33. Study of a woman. Ca. 1868–70.

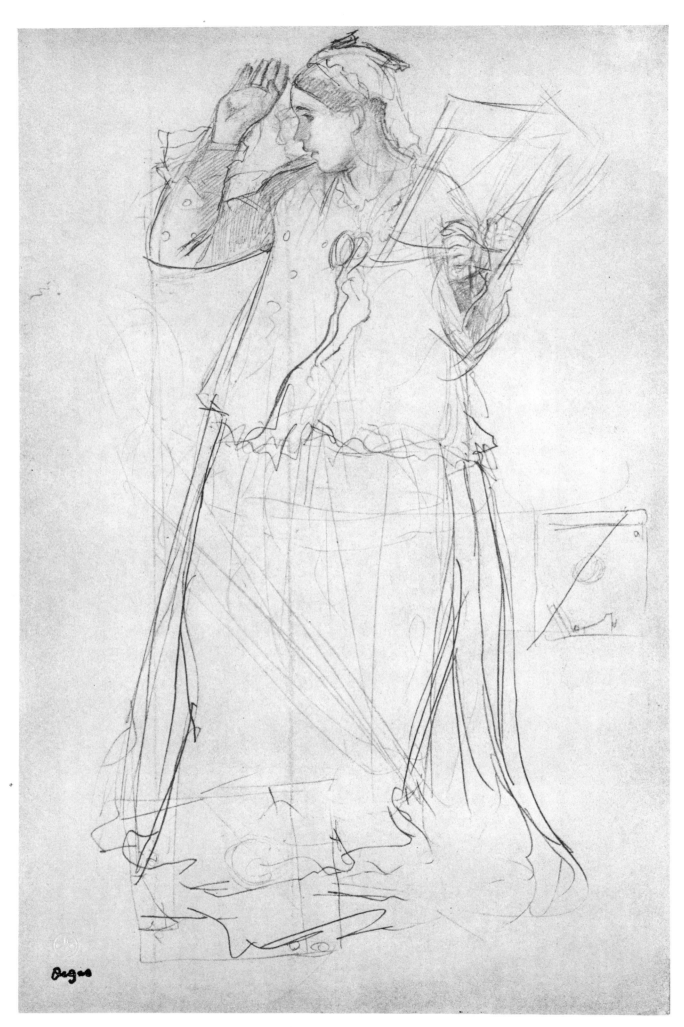

34. Study of a woman. Ca. 1868–70.

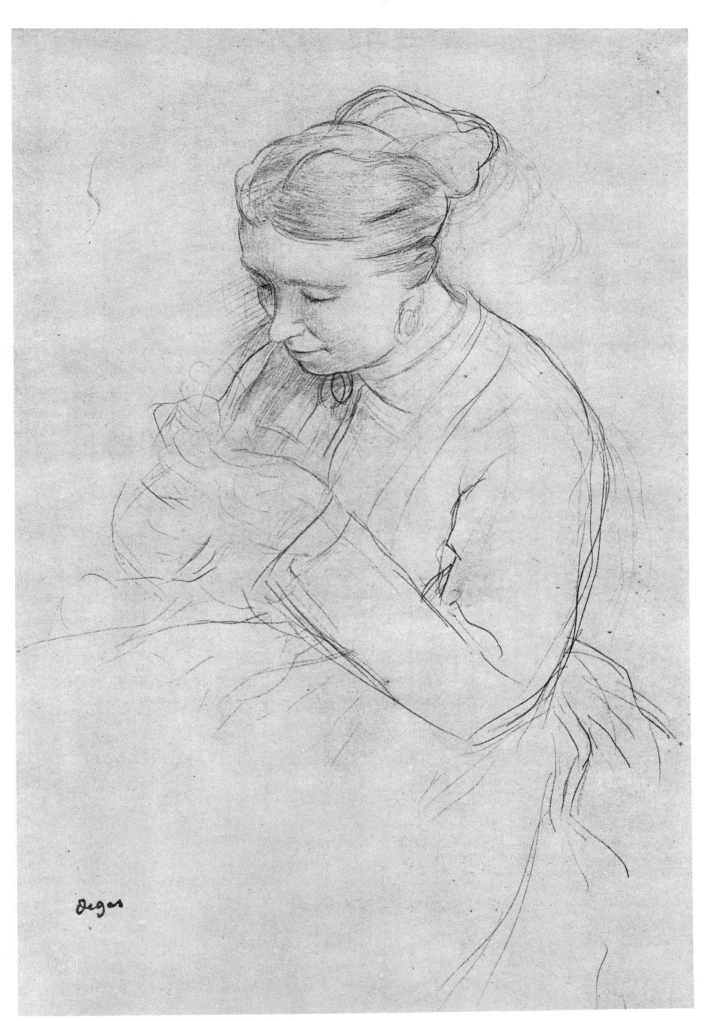

35. Woman sewing. Ca. 1868–70.

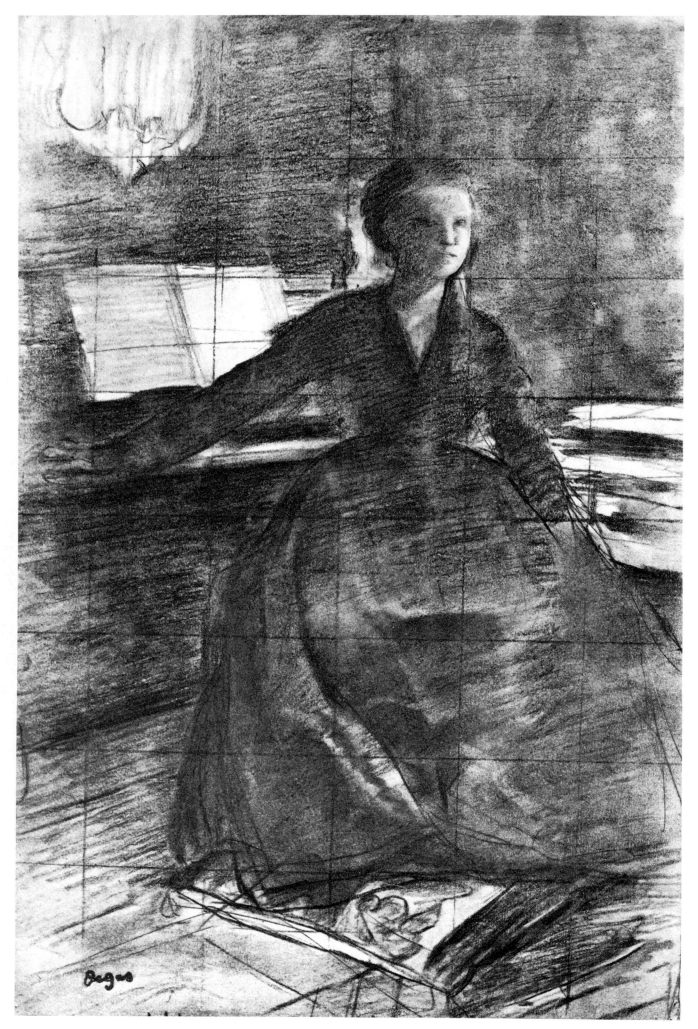

36. Portrait of Mme. Camus. Ca. 1869–70.

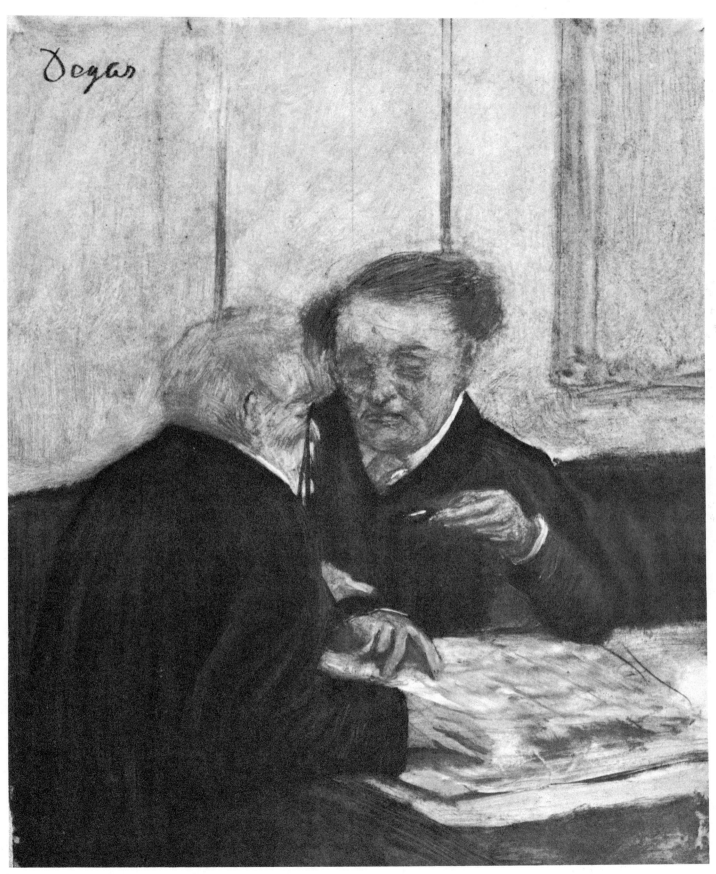

37. At the café. Ca. 1872–74.

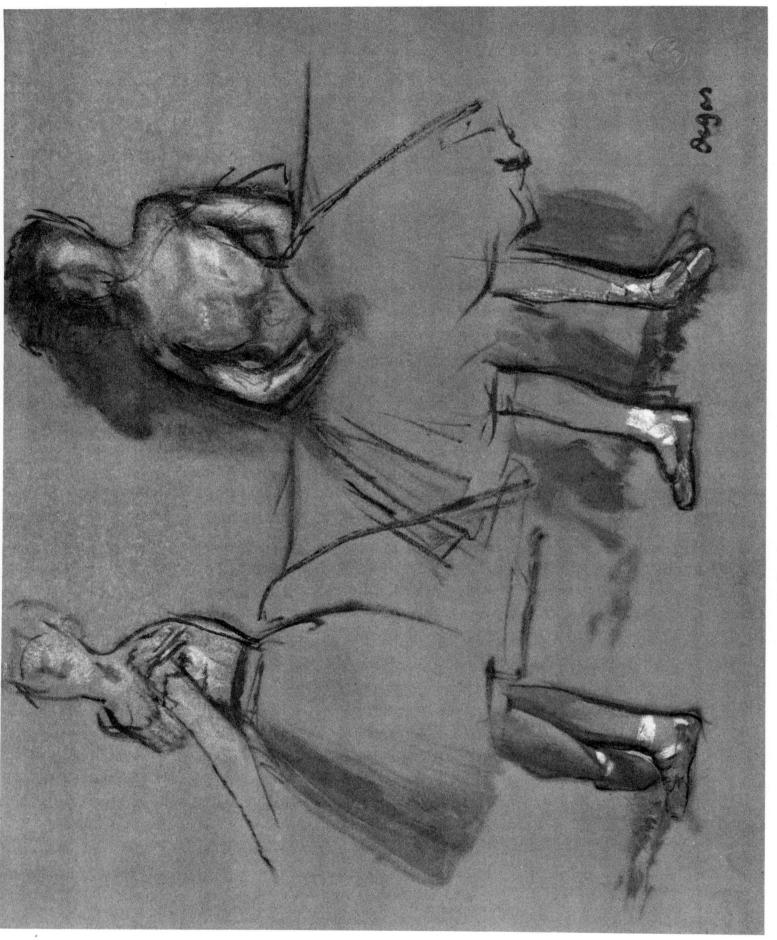

38. Two dancers leaning on the bar. Ca. 1872–75.

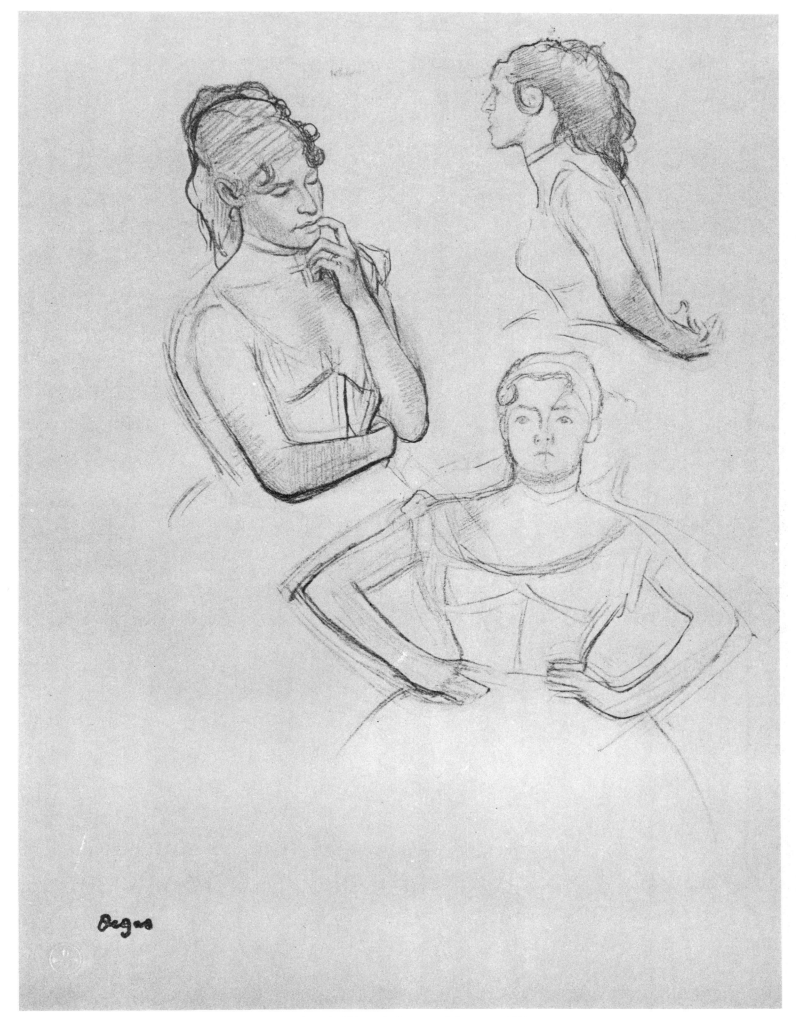

39. Three half-length figures of dancers. 1874.

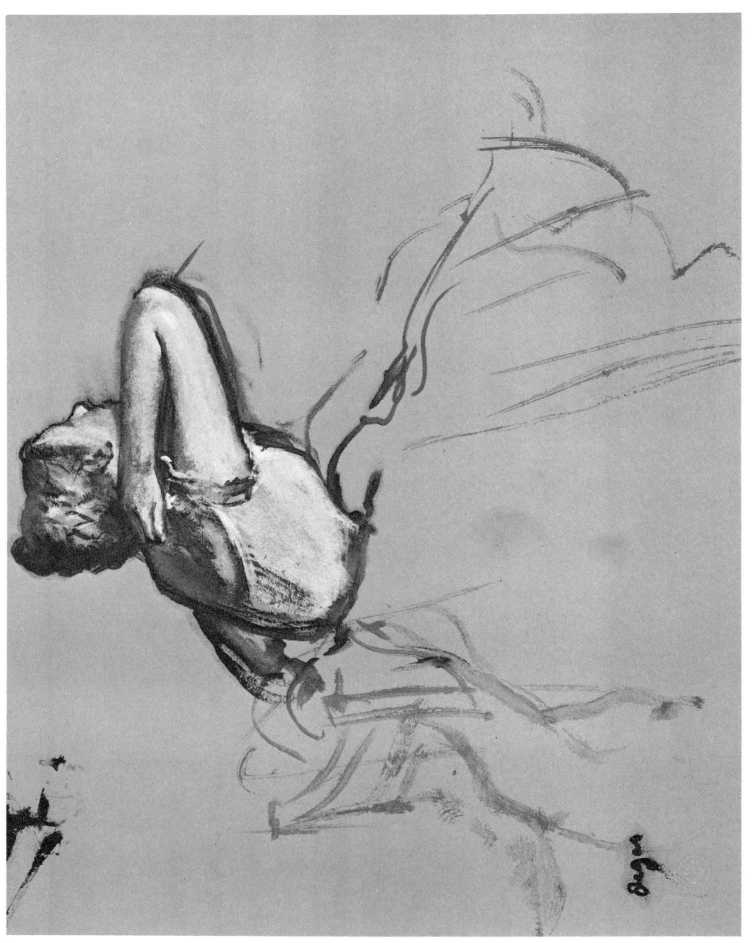

40. Seated dancer, her hand behind her neck. 1874.

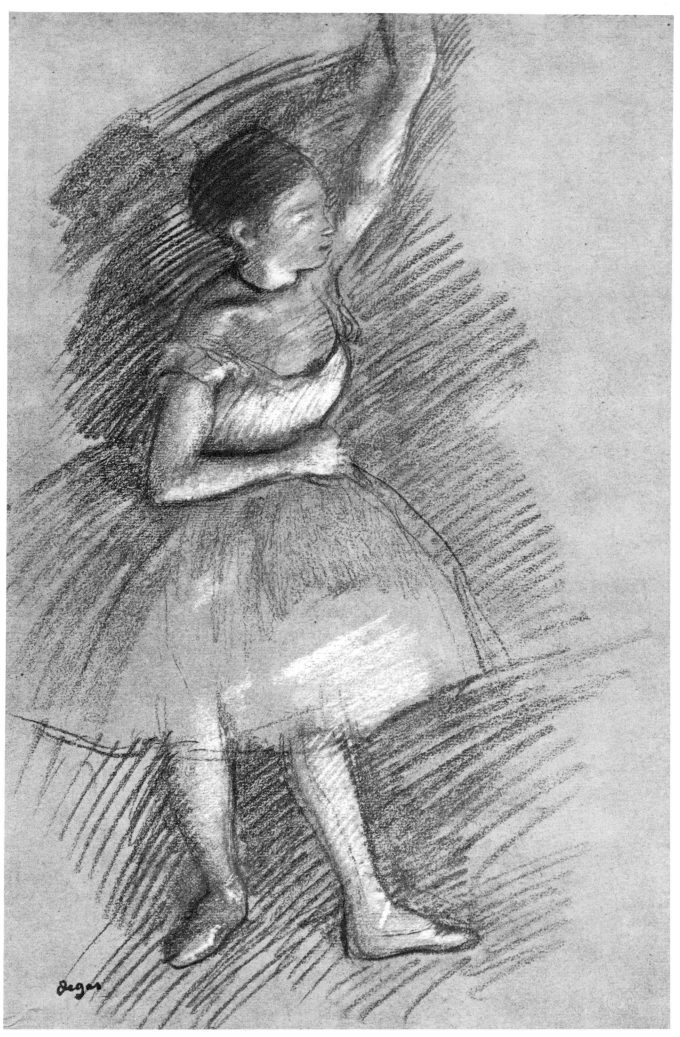

41. Standing dancer with her left arm raised. 1874.

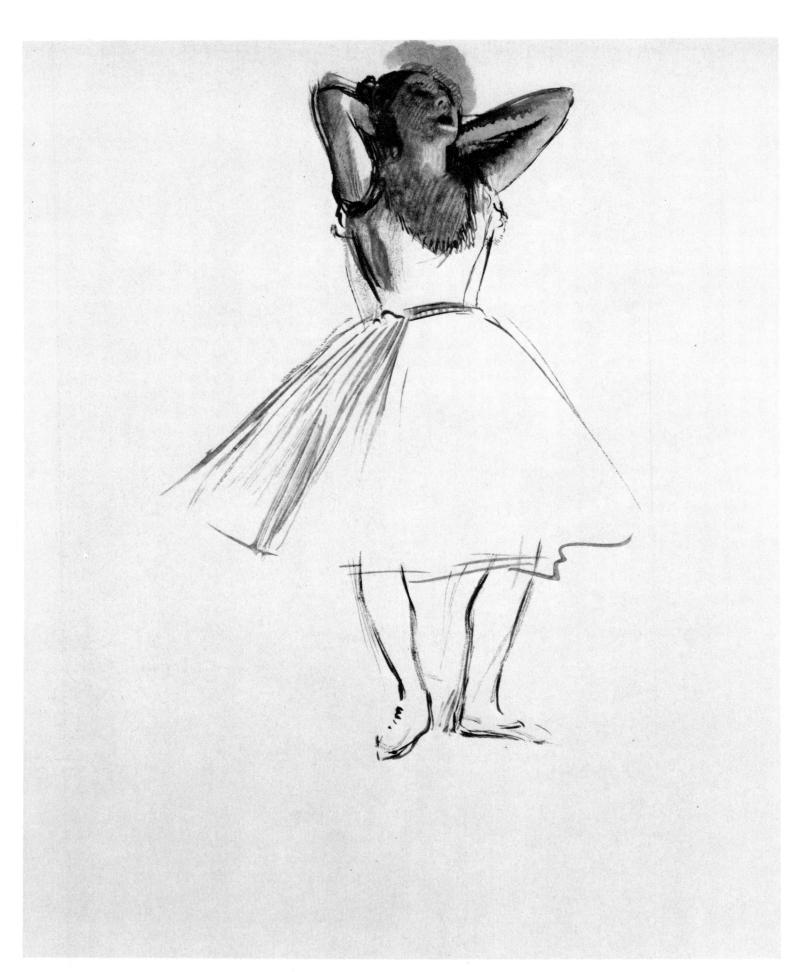

42.  Standing dancer with her arms behind her head. 1874.

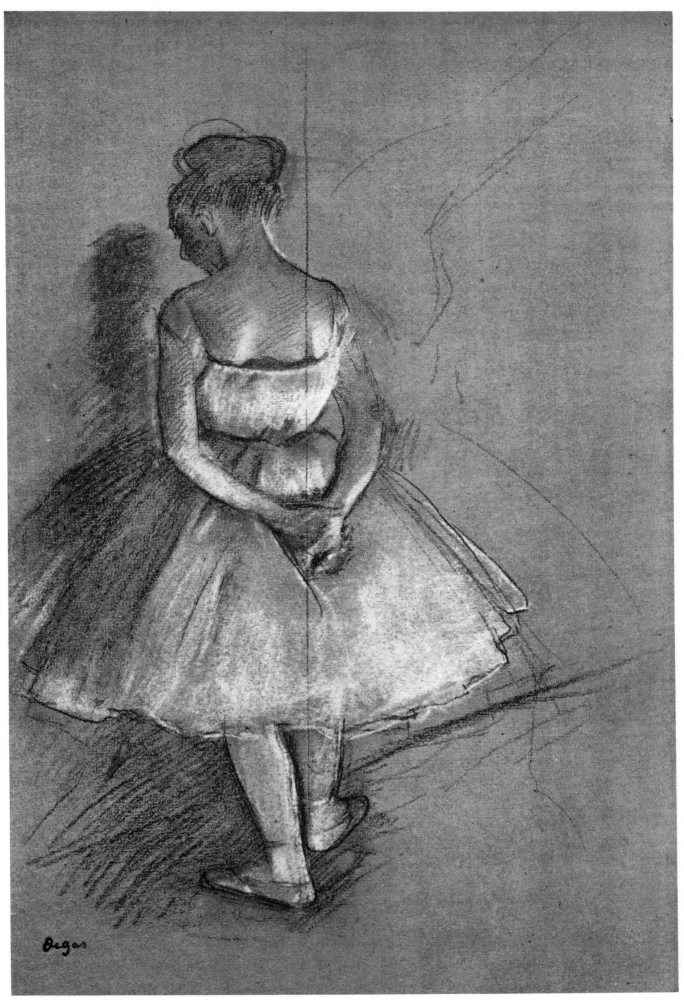

43. Standing dancer with her hands behind her back. 1874.

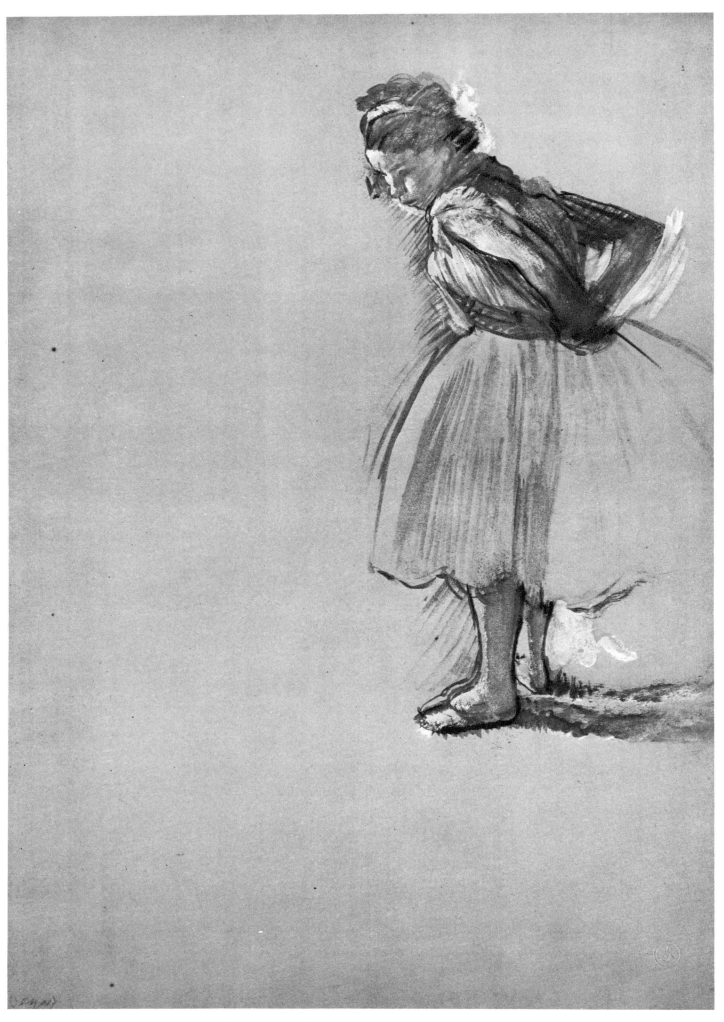

44. Standing dancer, three-quarter view, tying her belt. Ca. 1874.

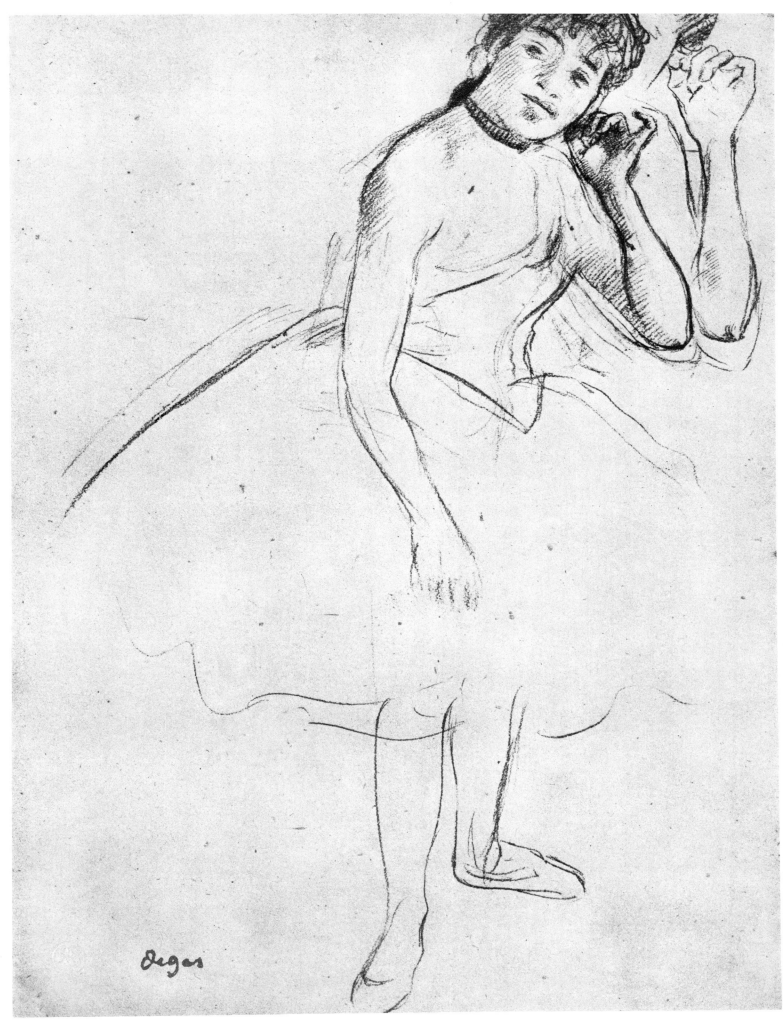

45.  Dancer touching her earring. 1874.

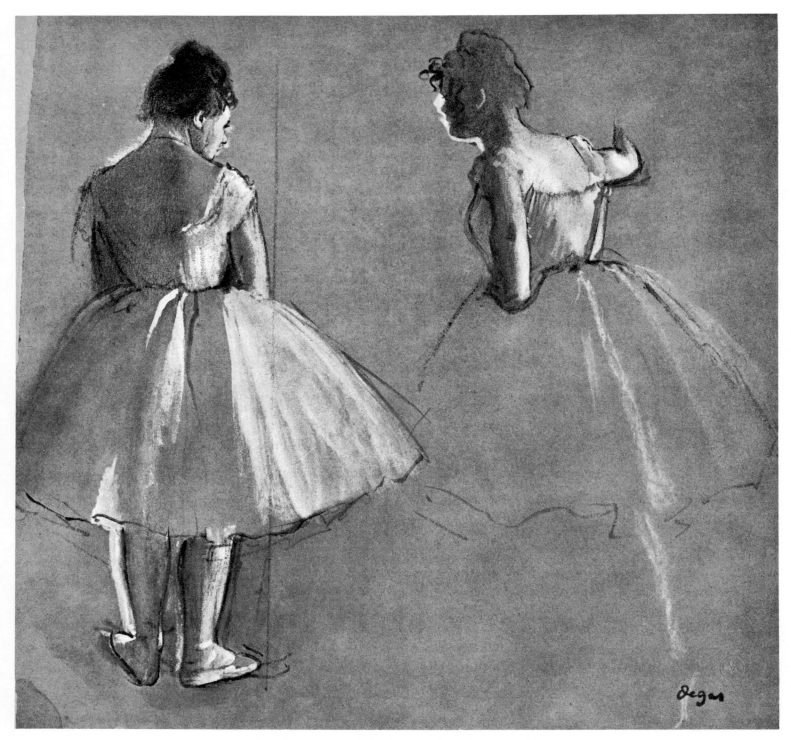

46. Two standing dancers, one in back view, the other in profile. Ca. 1874–75.

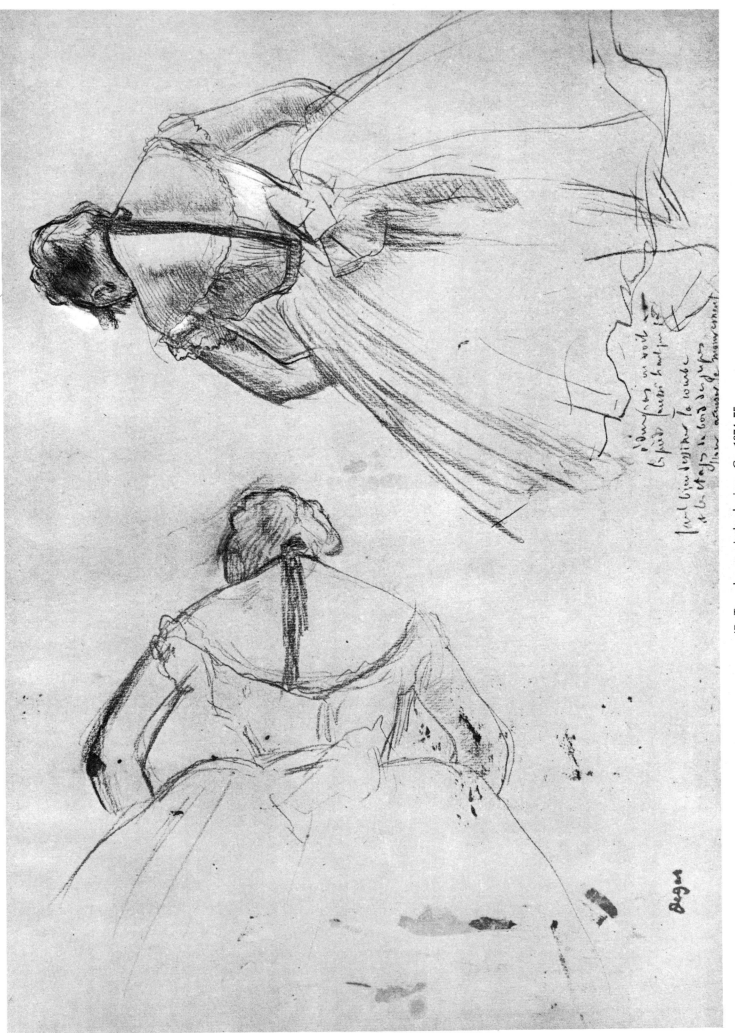

47. Two dancers in back view. Ca. 1874-75.

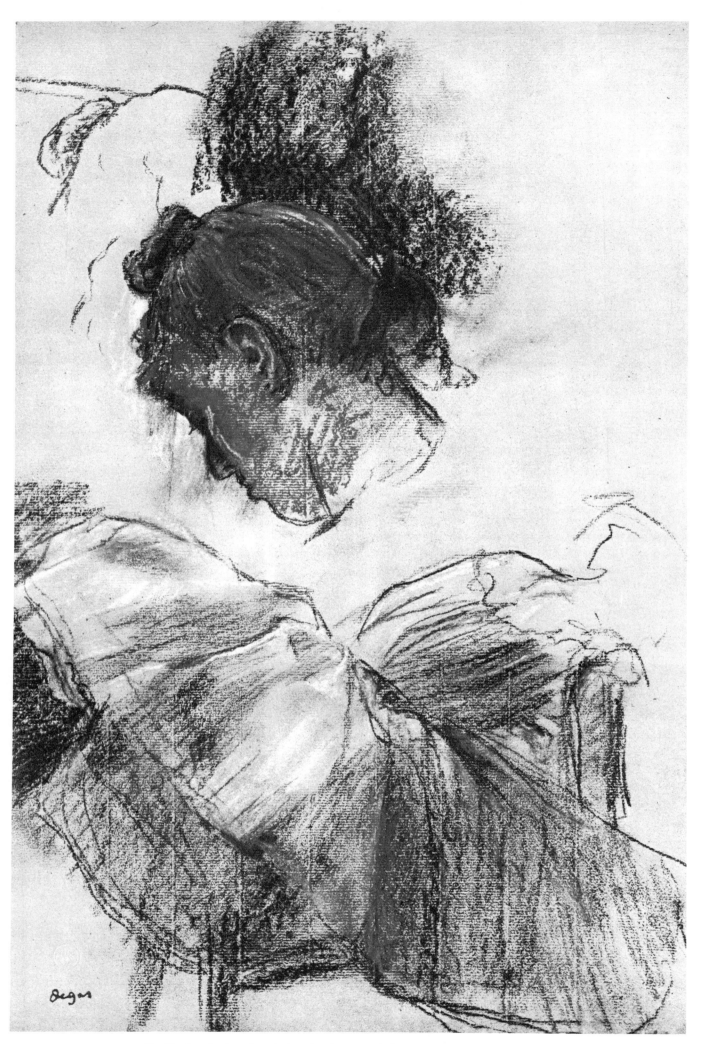

48. Study of a head and sketch of a seated dancer stooping. Ca. 1874–75.

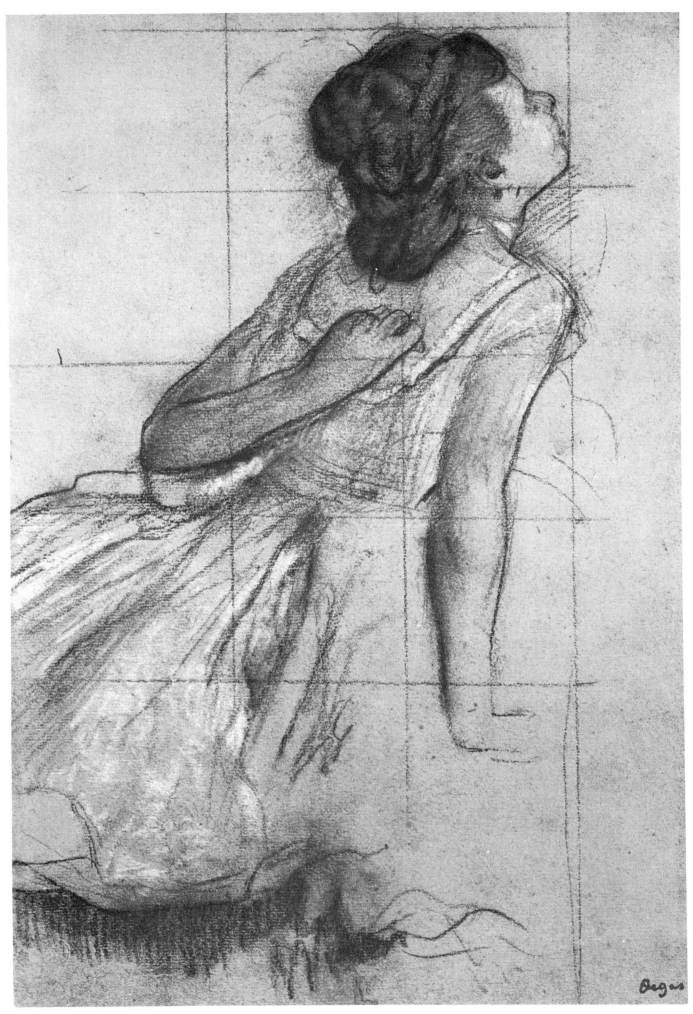

49. Dancer scratching her back. Ca. 1874–75.

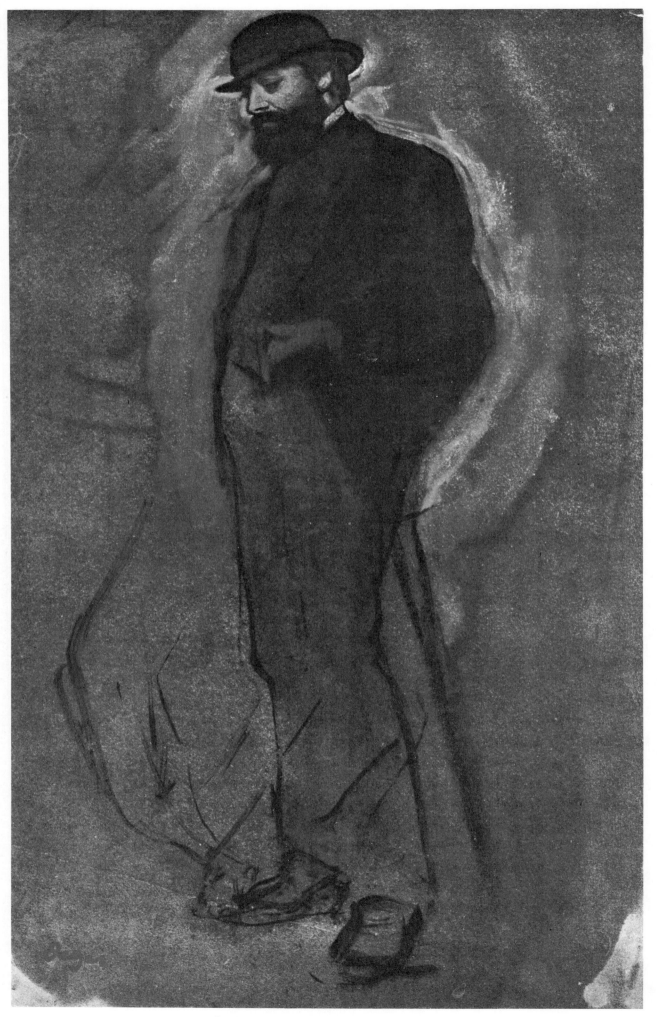

50. Standing man with a derby and an umbrella. Ca. 1875.

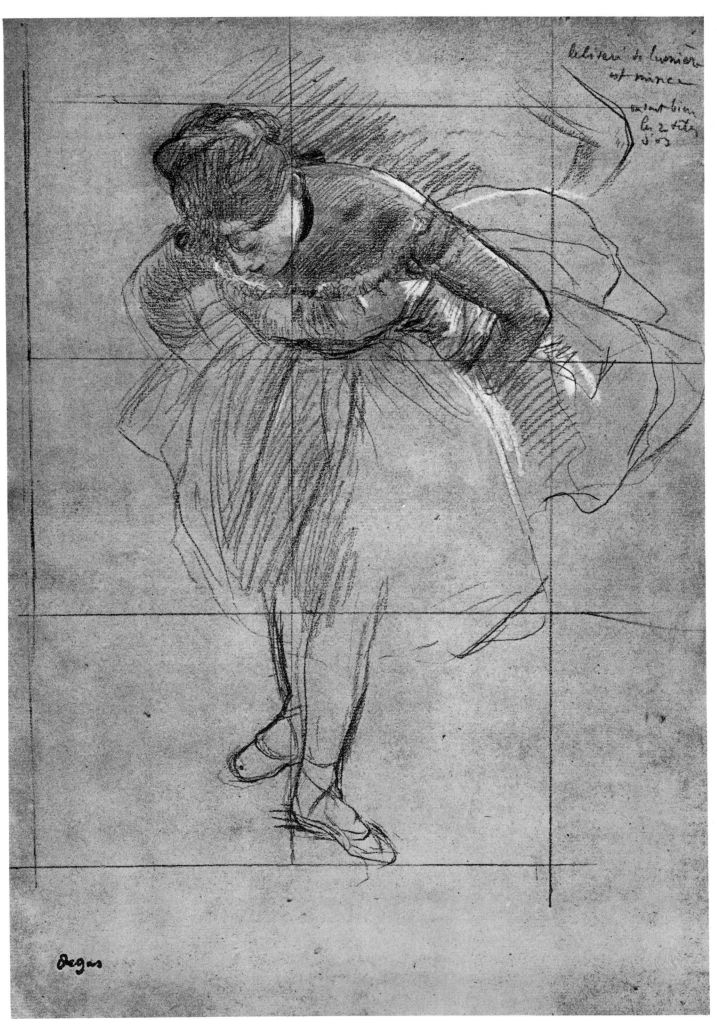

51. Dancer leaning forward. Ca. 1875.

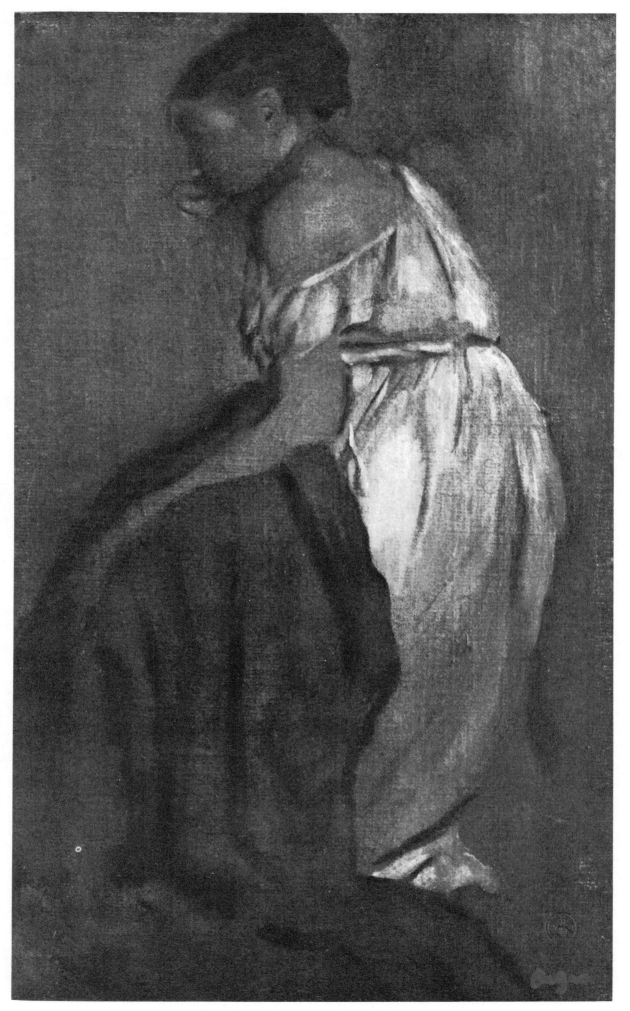

52. Half-dressed young woman. Ca. 1875.

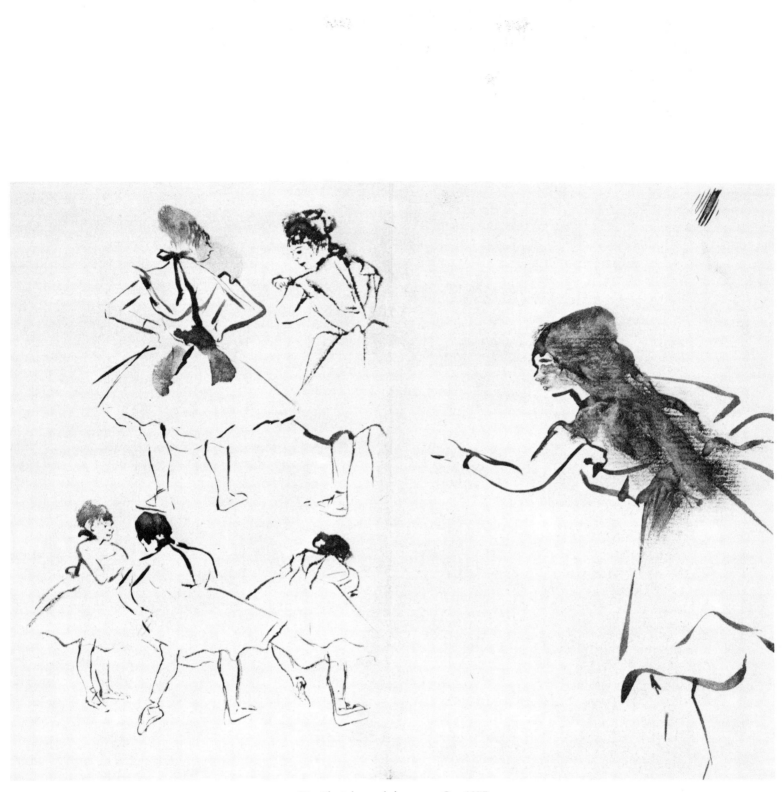

53. Sketches of dancers. Ca. 1875.

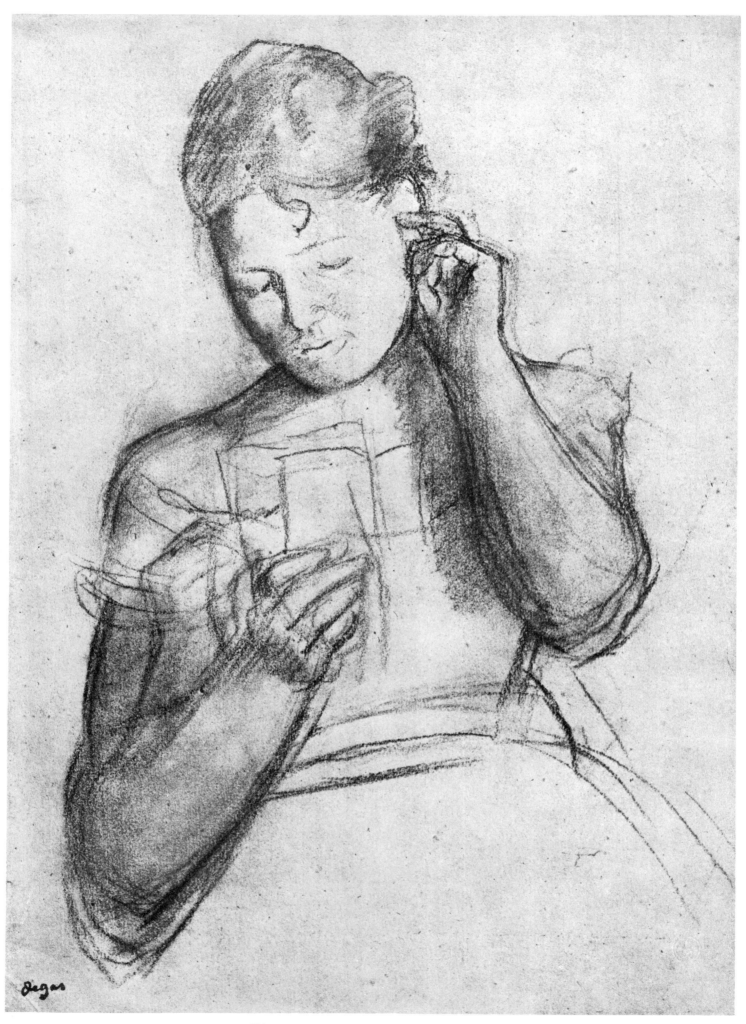

54. Half-length figure of a dancer reading a letter. 1875.

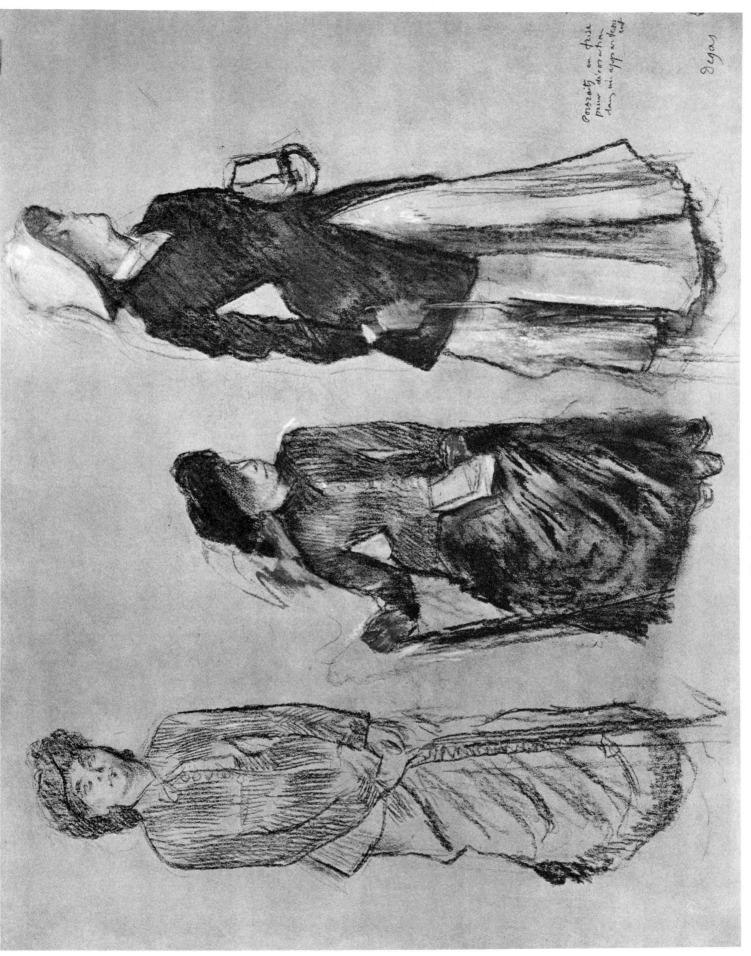

55. Three ladies in street dress. Ca. 1875–76.

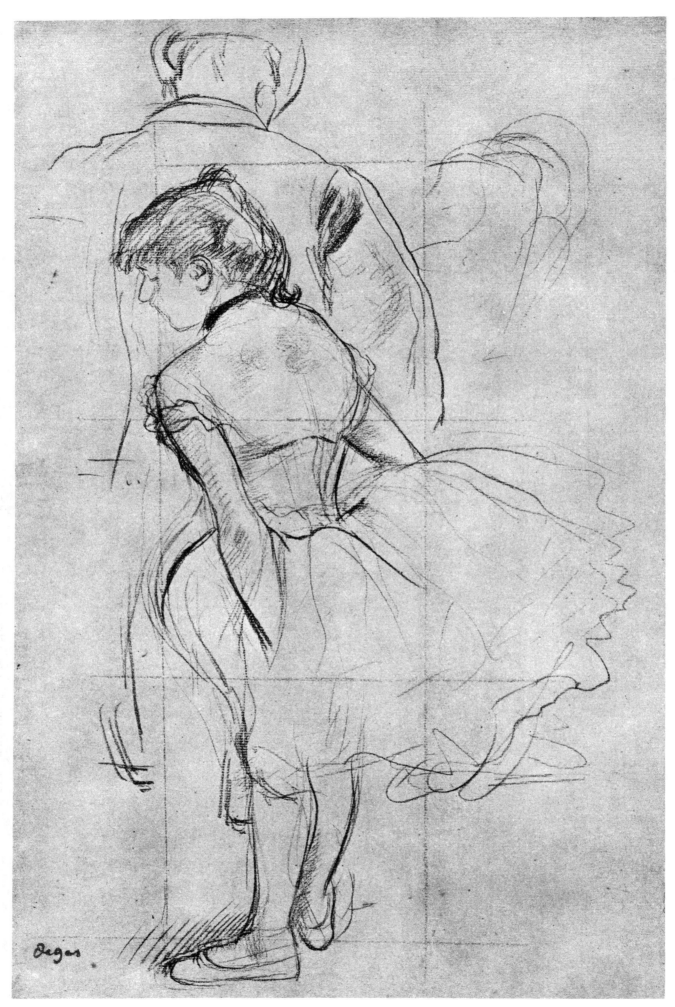

56. Standing dancer fluffing up her dress. Ca. 1875–76.

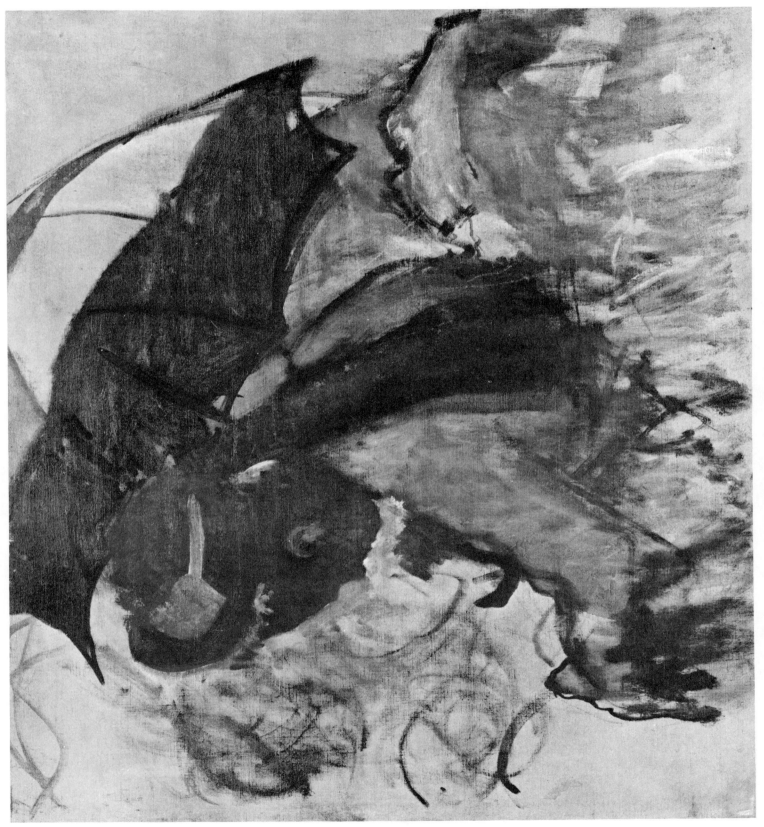

57. Woman holding a parasol. Ca. 1875–76.

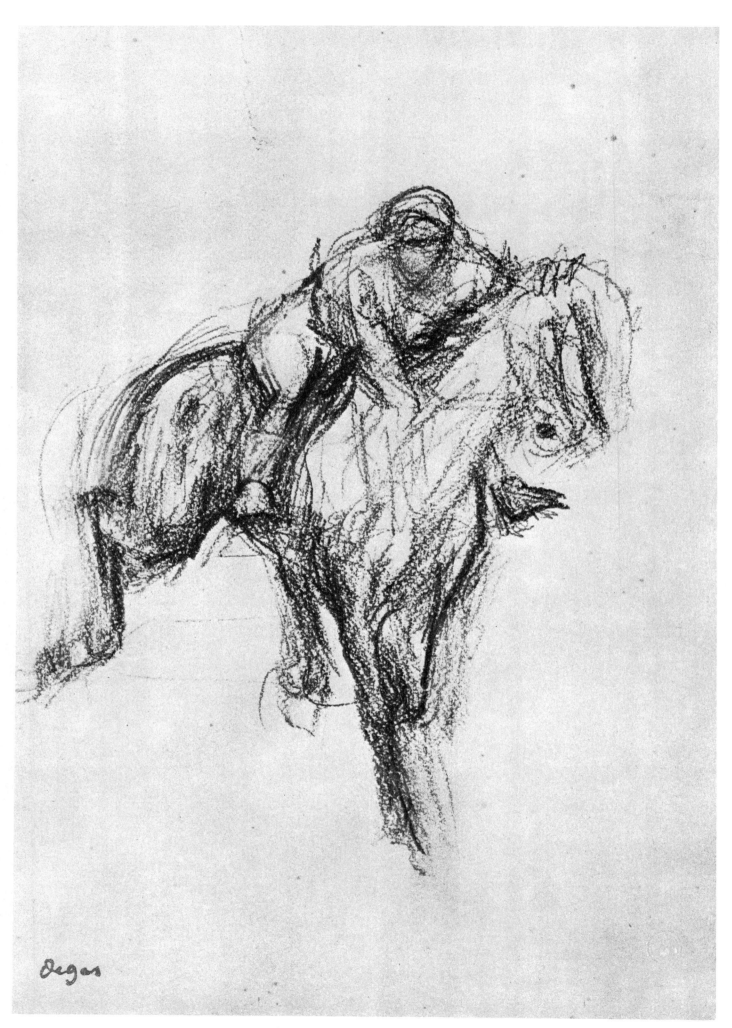

58. Jockey on a galloping horse. Ca. 1875–76.

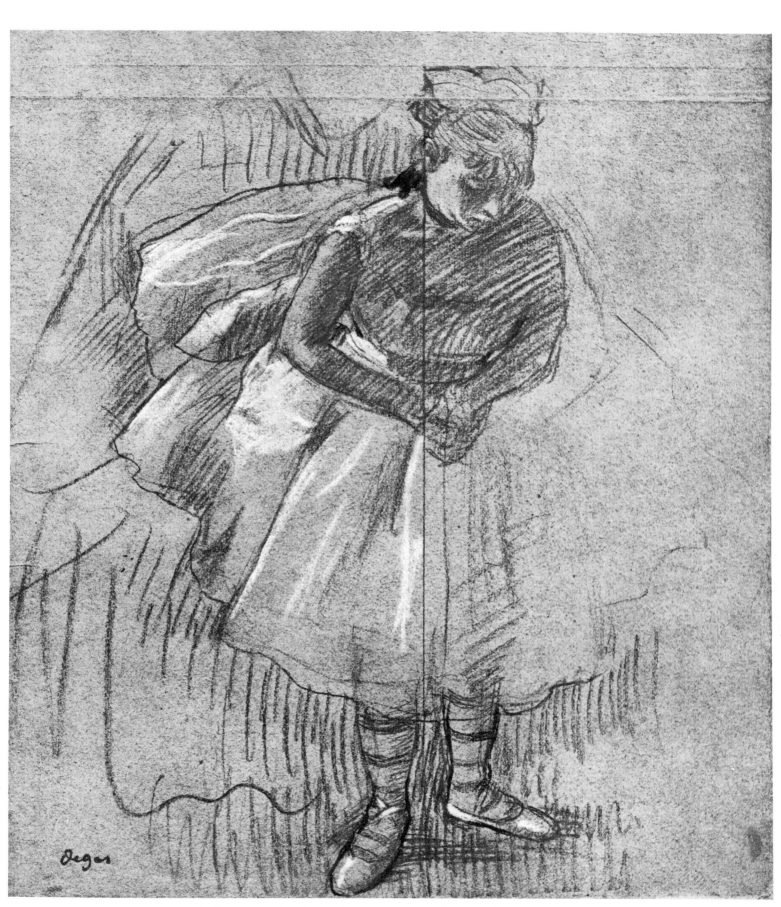

59. Dancer leaning forward as a dresser stitches her dress. Ca. 1875–76.

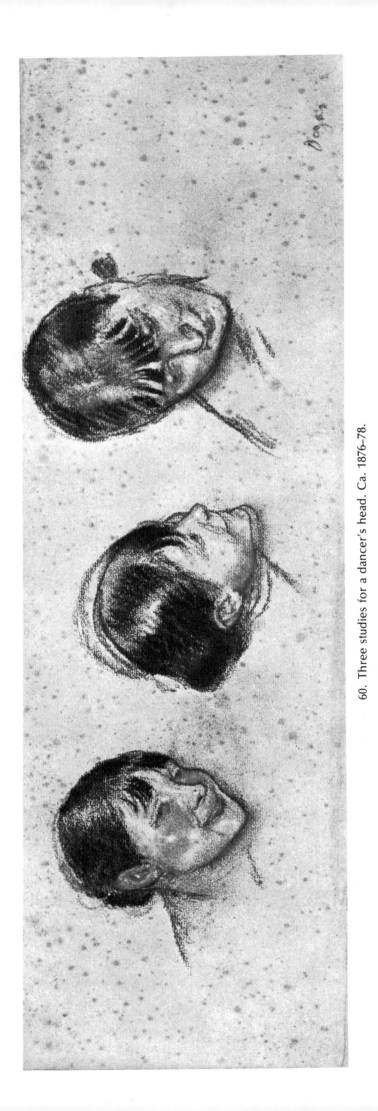

60. Three studies for a dancer's head. Ca. 1876–78.

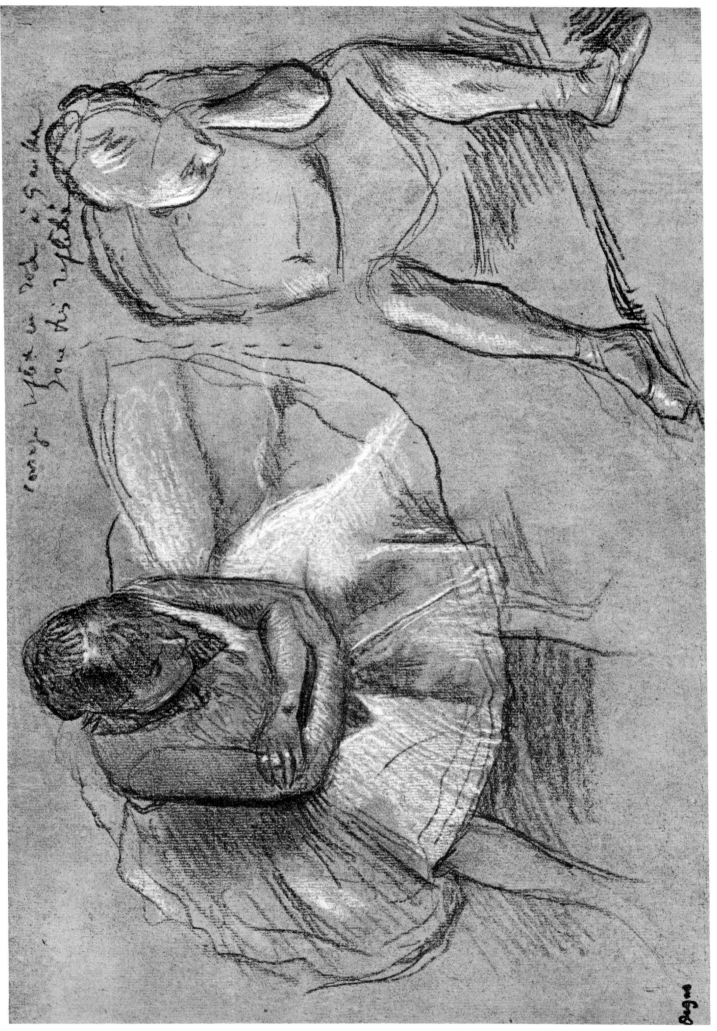

61. Two dancers resting. Ca. 1876–80.

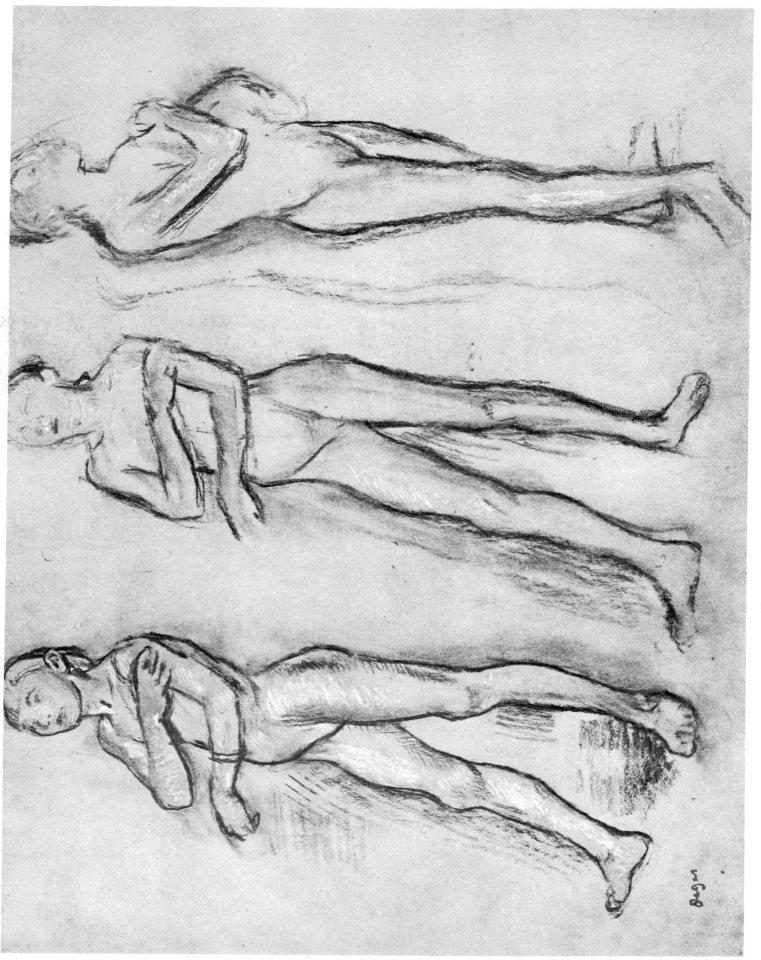

62. Three sketches of a nude young dancer. Ca. 1876–80.

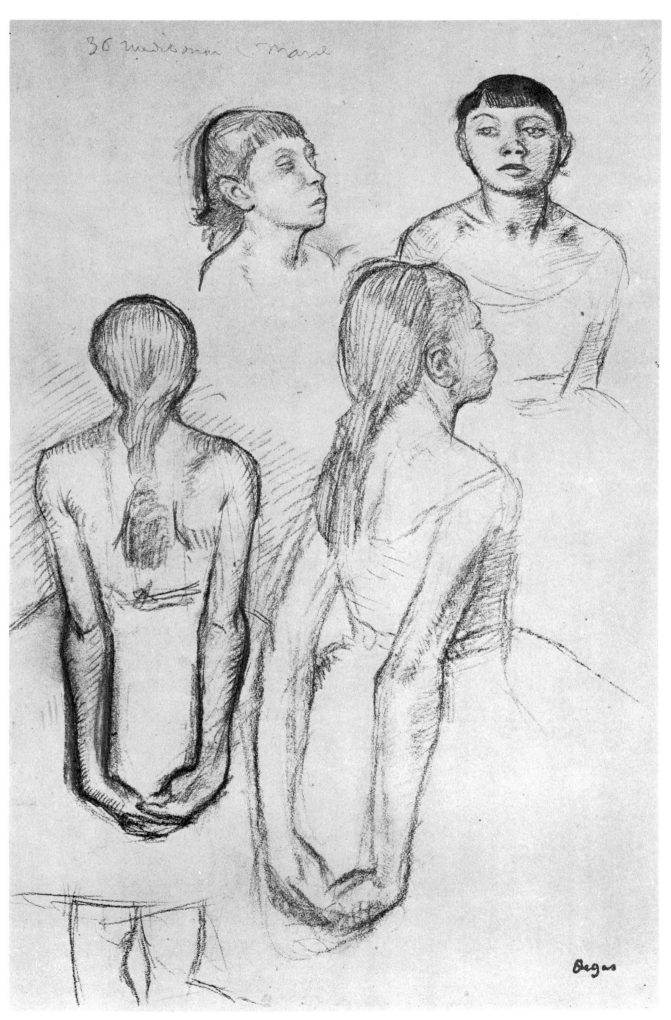

63. Four sketches of a young dancer. Ca. 1876–80.

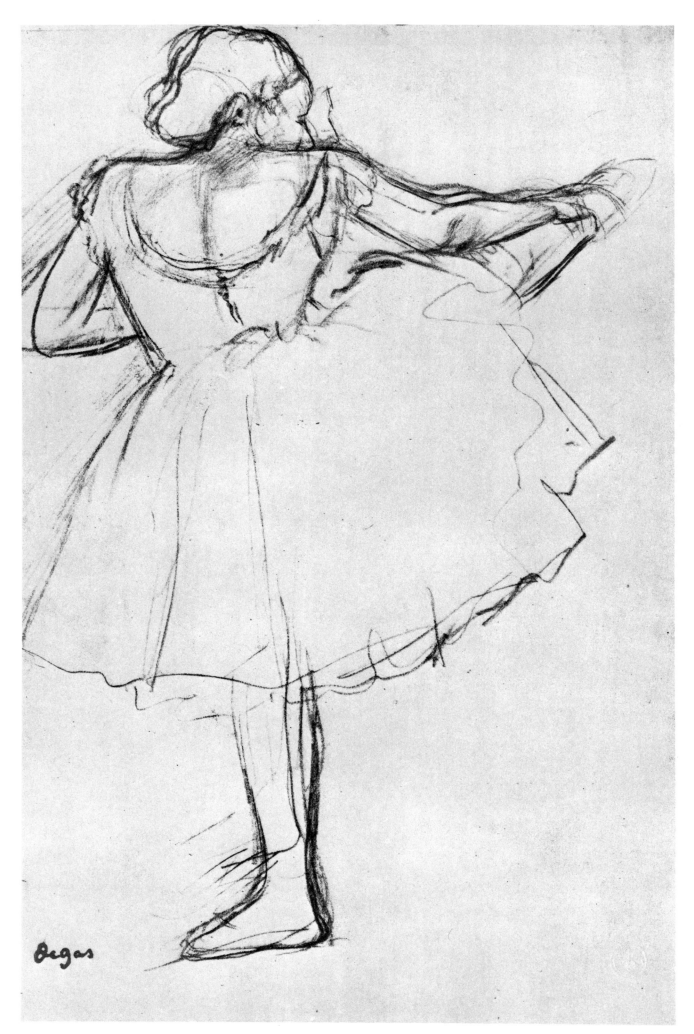

64. Dancer at the bar. 1877.

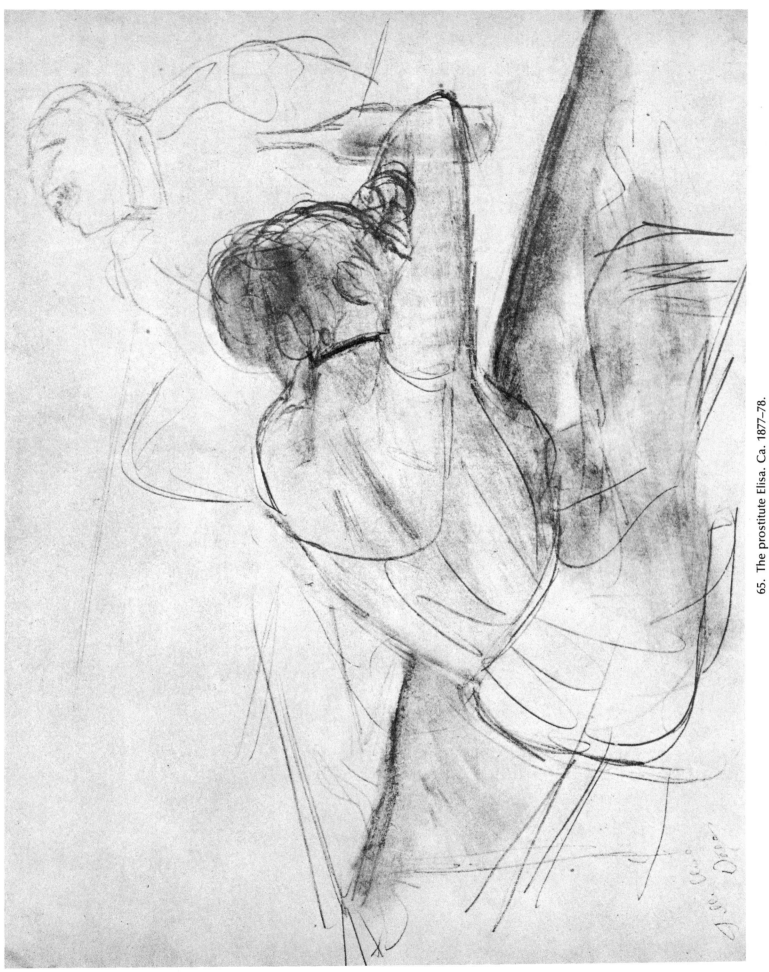

65. The prostitute Elisa. Ca. 1877–78.

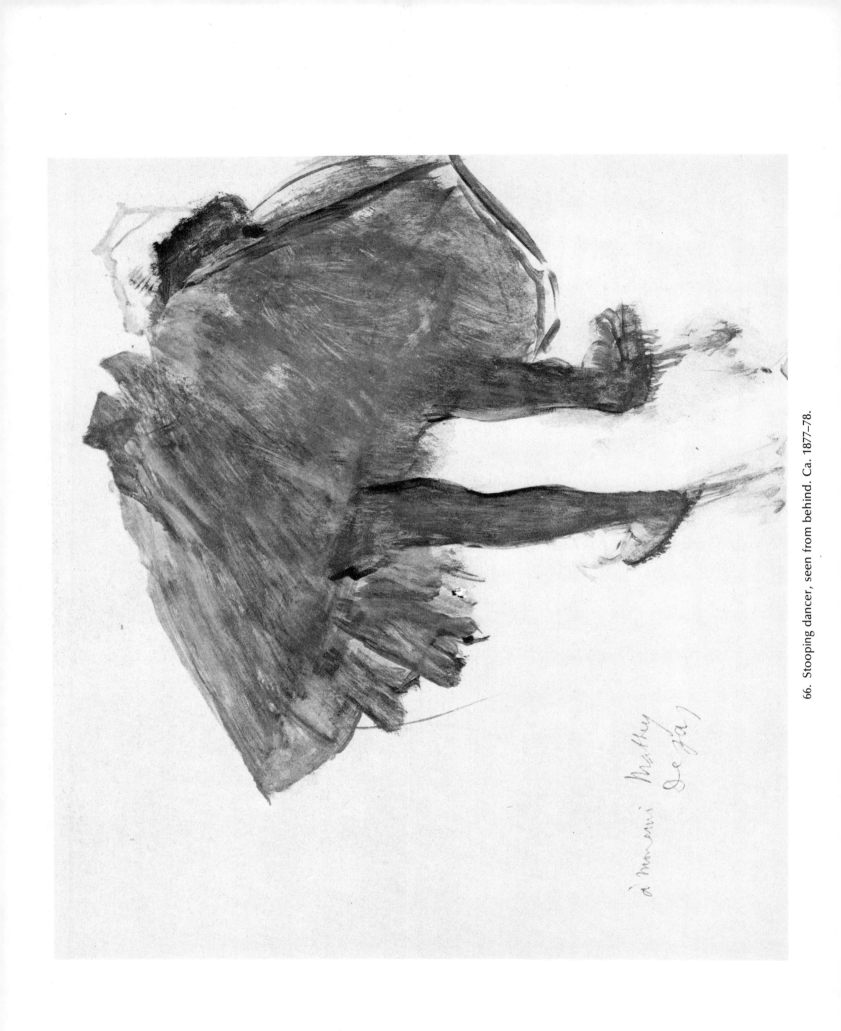

66. Stooping dancer, seen from behind. Ca. 1877–78.

67. Mélina Darde. Signed and dated December 1878.

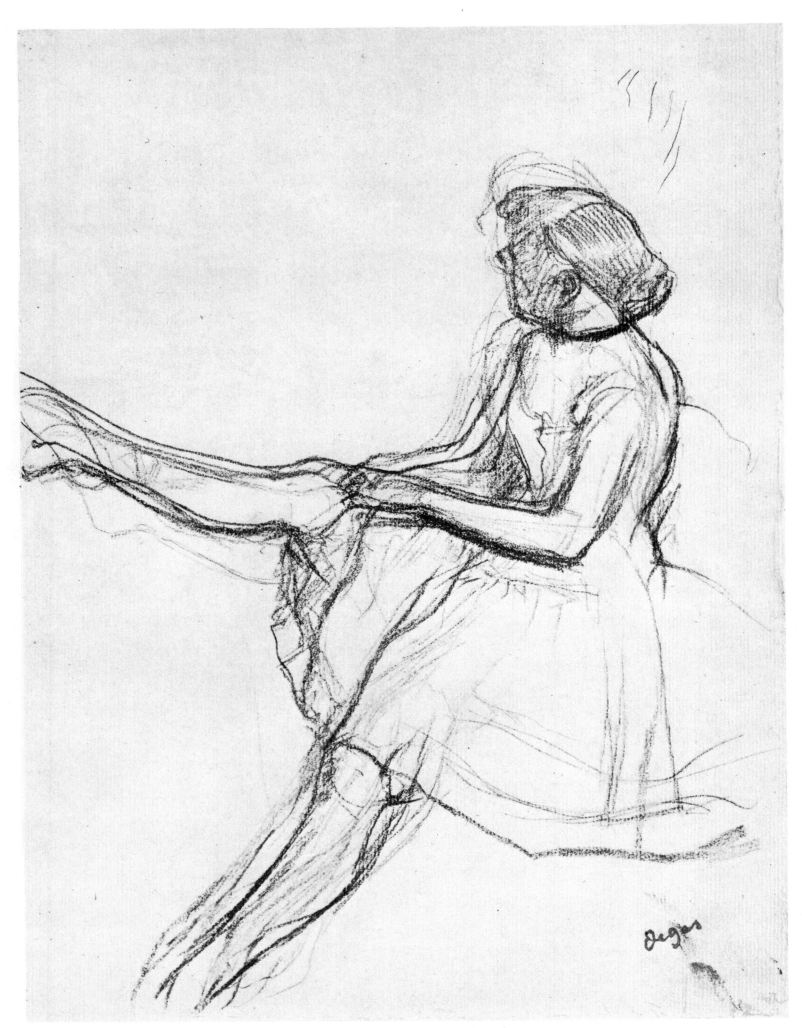

68. Seated dancer pulling up her tights. Ca. 1878–80.

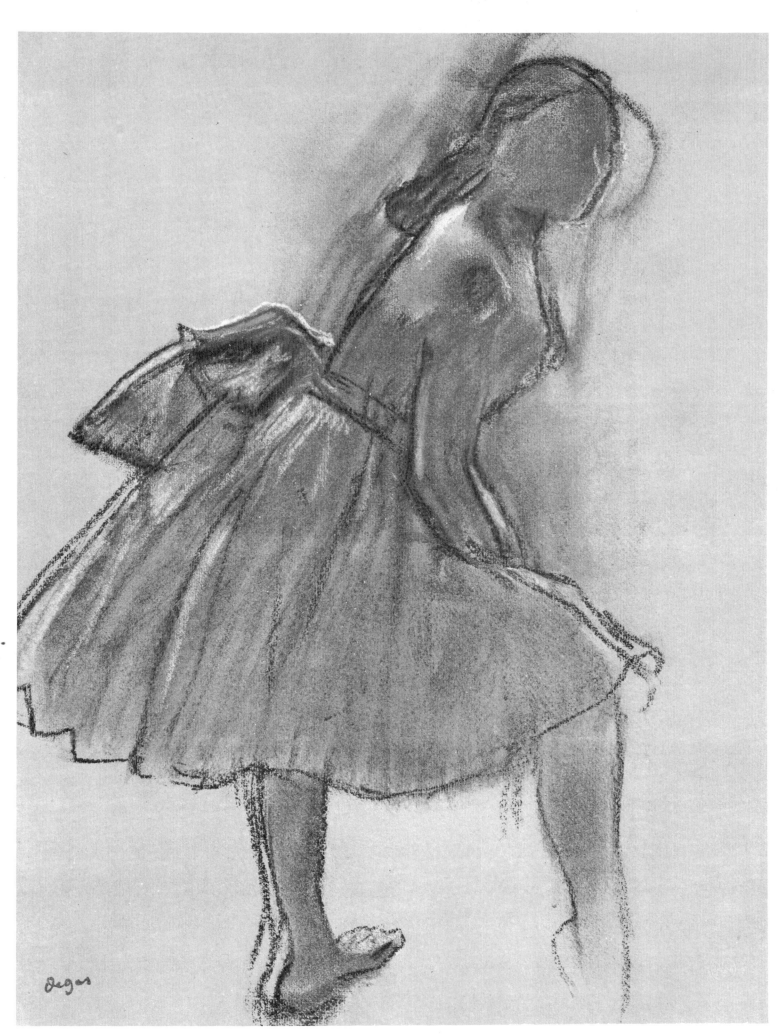

69. Standing dancer in profile. Ca. 1878–80.

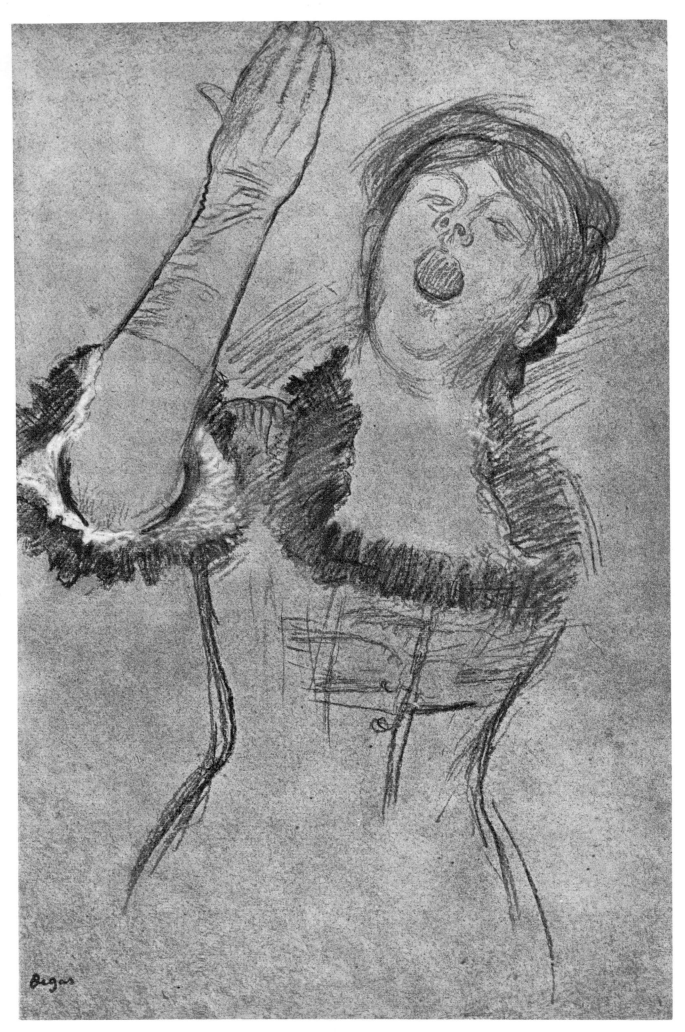

70. *Café-concert* singer. Ca. 1878–80.

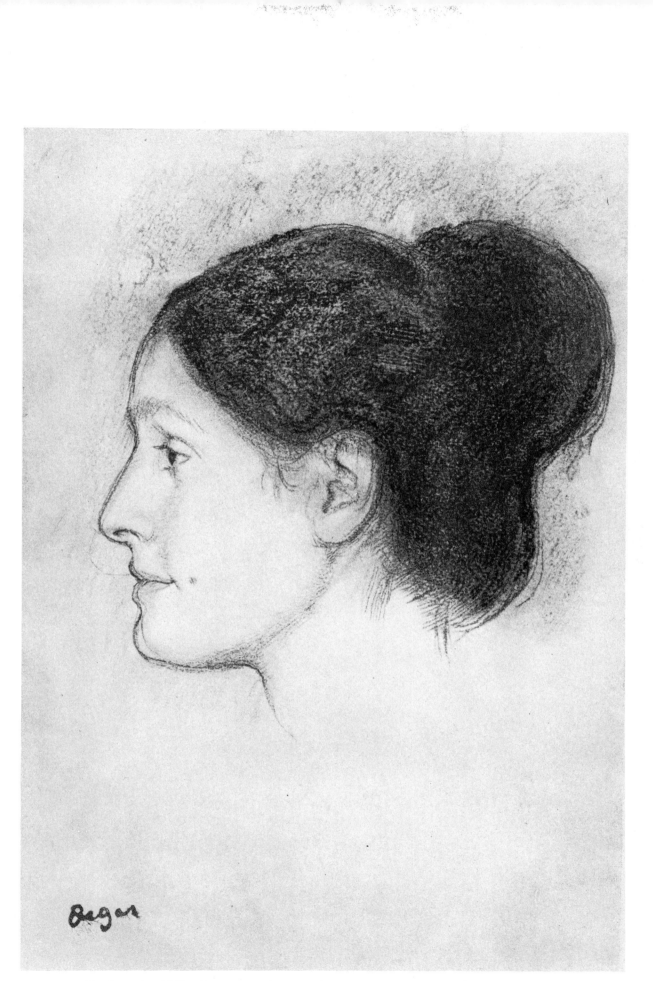

71. Portrait of Mlle. Hortense Valpinçon (later Mme. Jacques Fourchy). Ca. 1878–80.

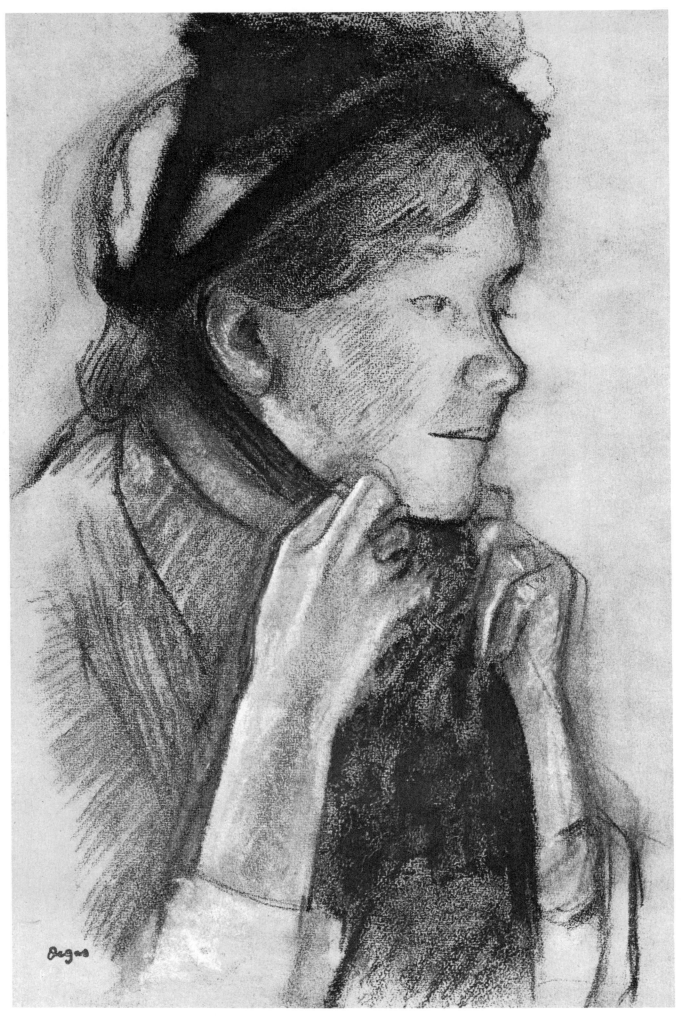

72. Woman tying the ribbons of her hat. Ca. 1878–82.

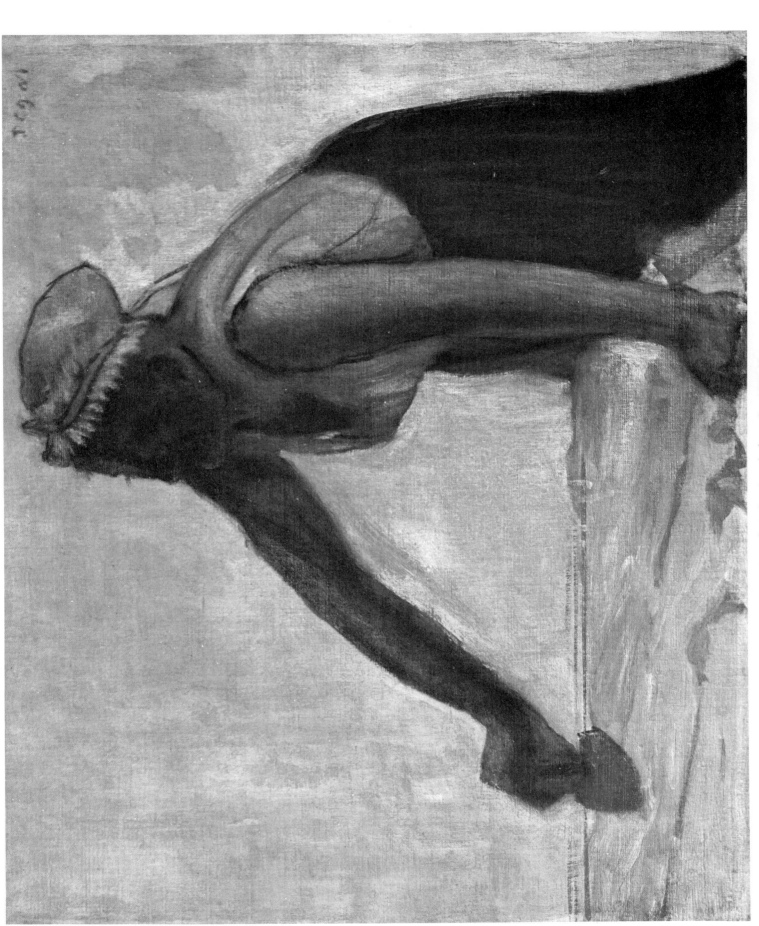

73. Laundress ironing clothes. Ca. 1878–82.

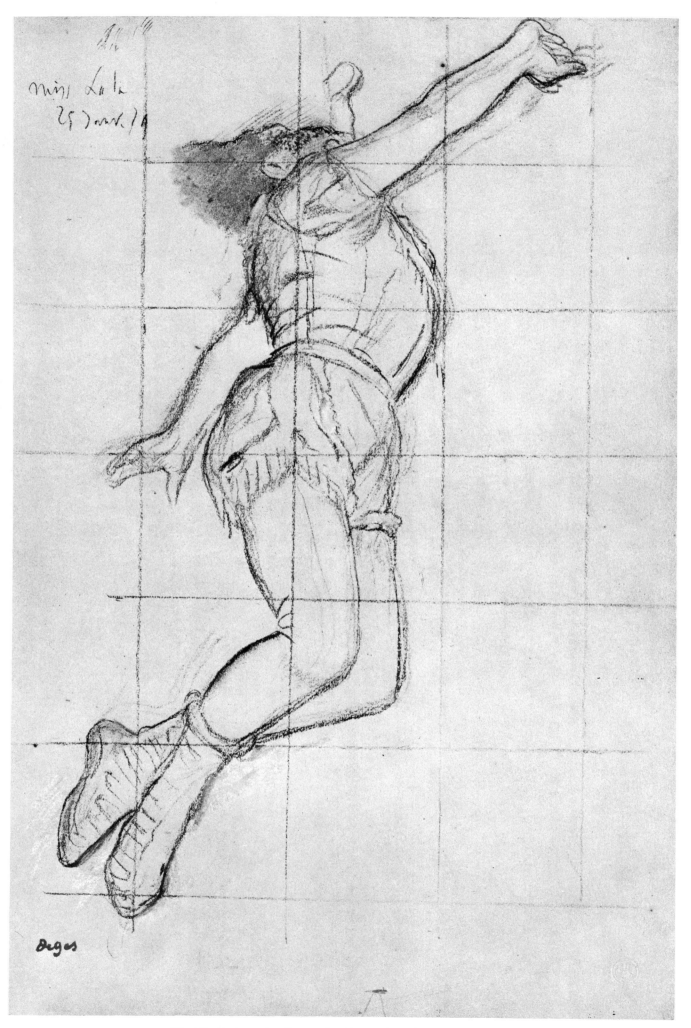

74. Miss Lala at the Fernando Circus. Dated January 25, 1879.

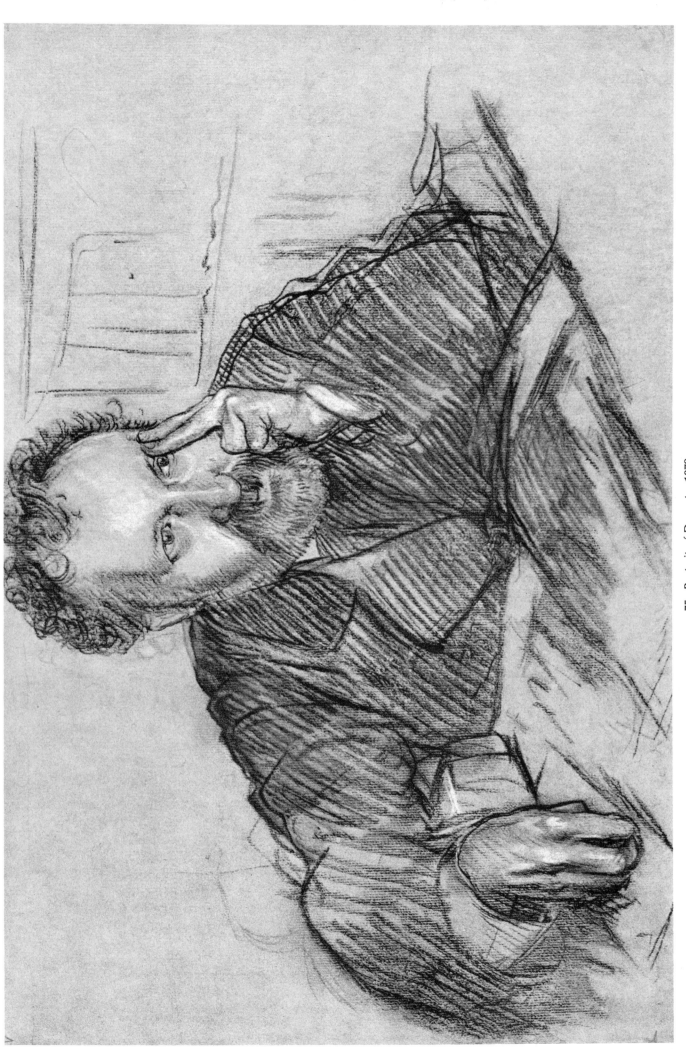

75. Portrait of Duranty. 1879.

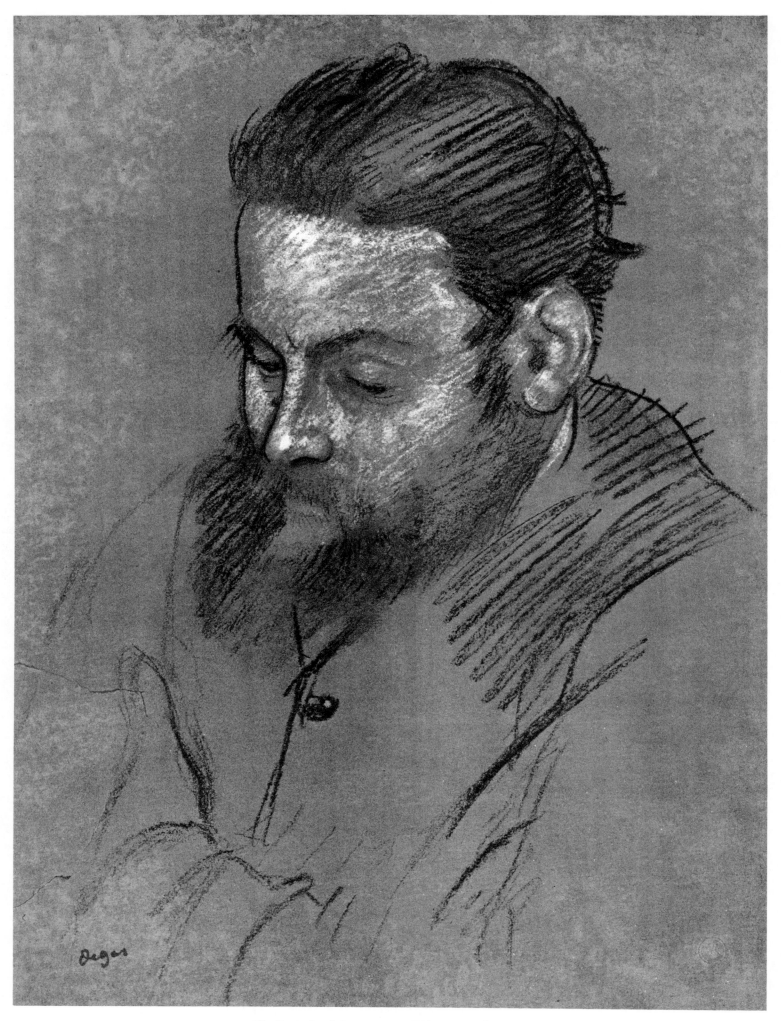

76. Portrait of the engraver Diégo Martelli. 1879.

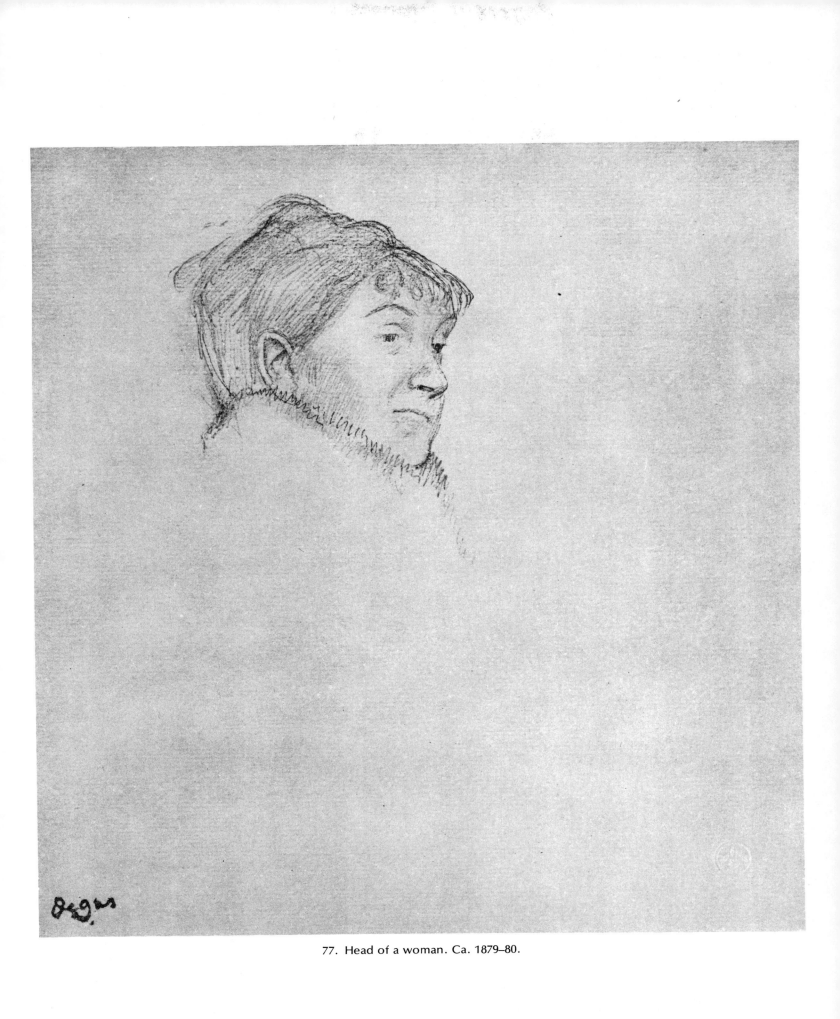

77. Head of a woman. Ca. 1879–80.

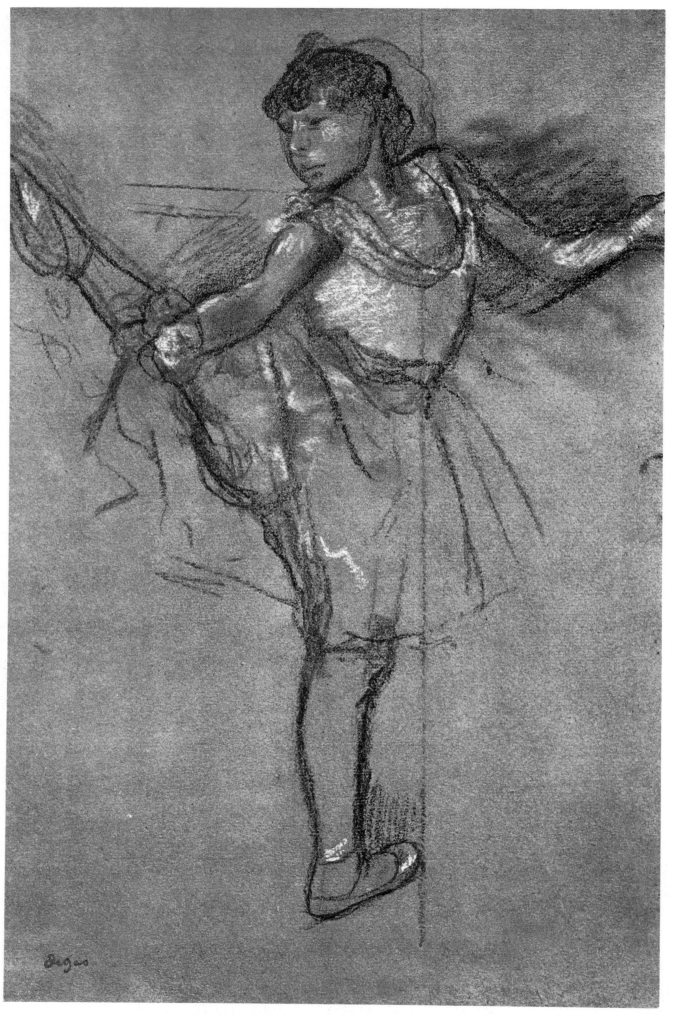

78. Standing dancer with her right leg raised. Ca. 1879–82.

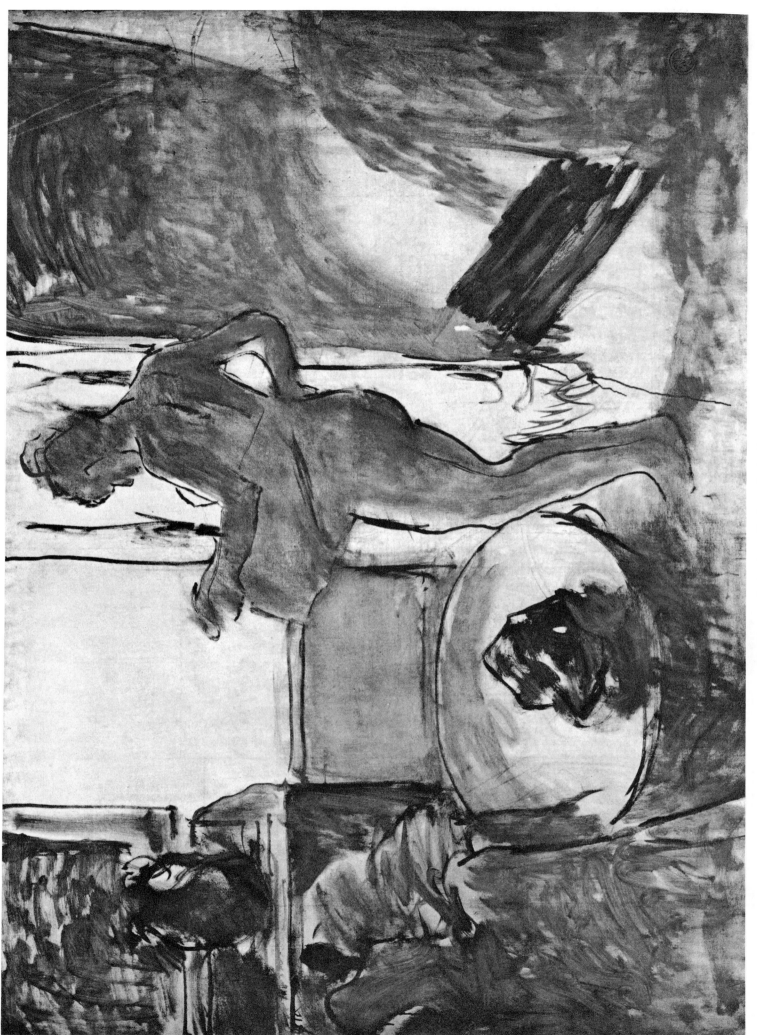

79. Woman drying herself after a bath. Ca. 1880–82.

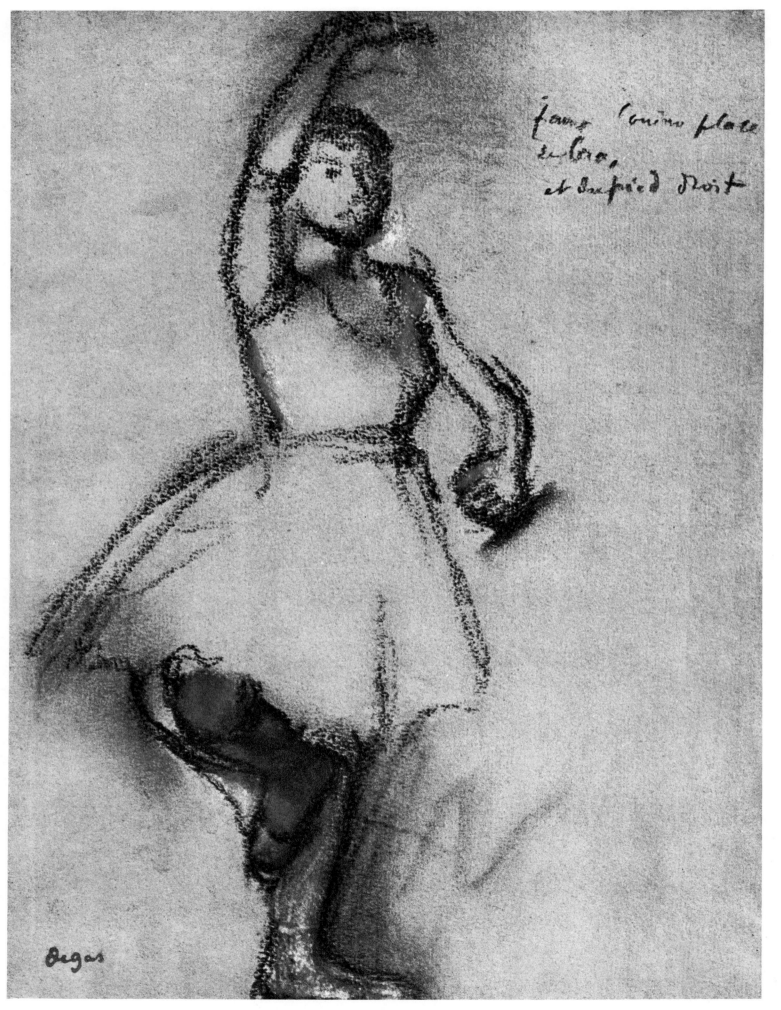

80. Dancer standing on one leg with one arm raised. Ca. 1882–85.

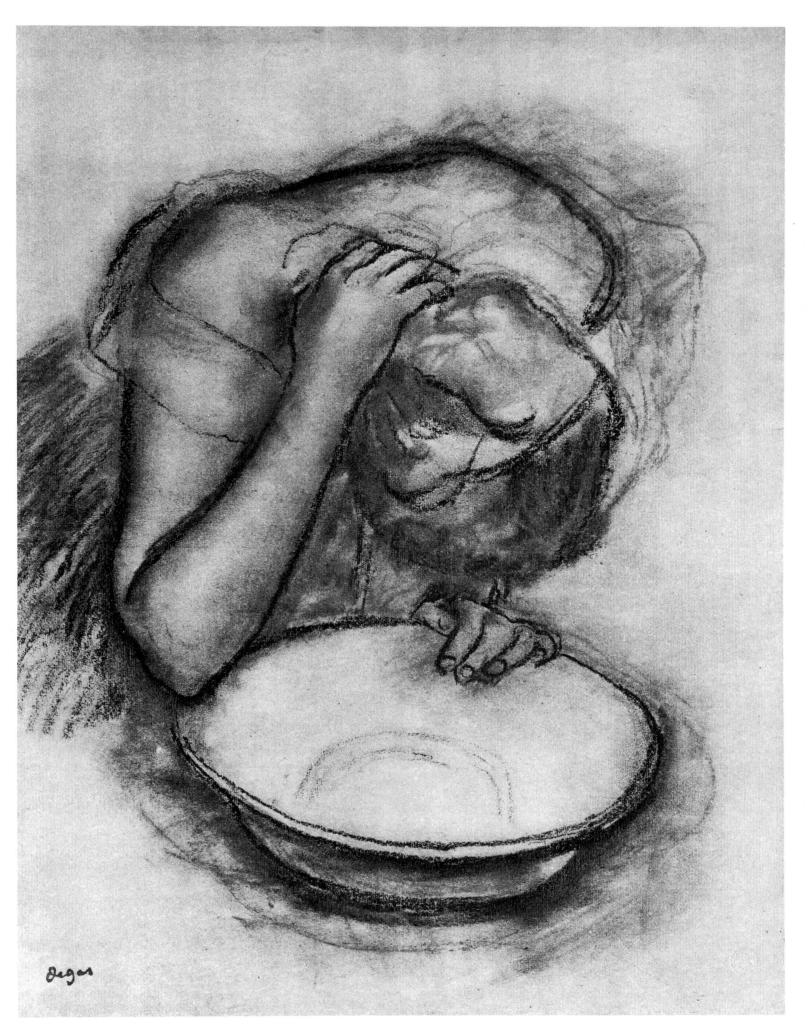

81. Woman washing. Ca. 1883.

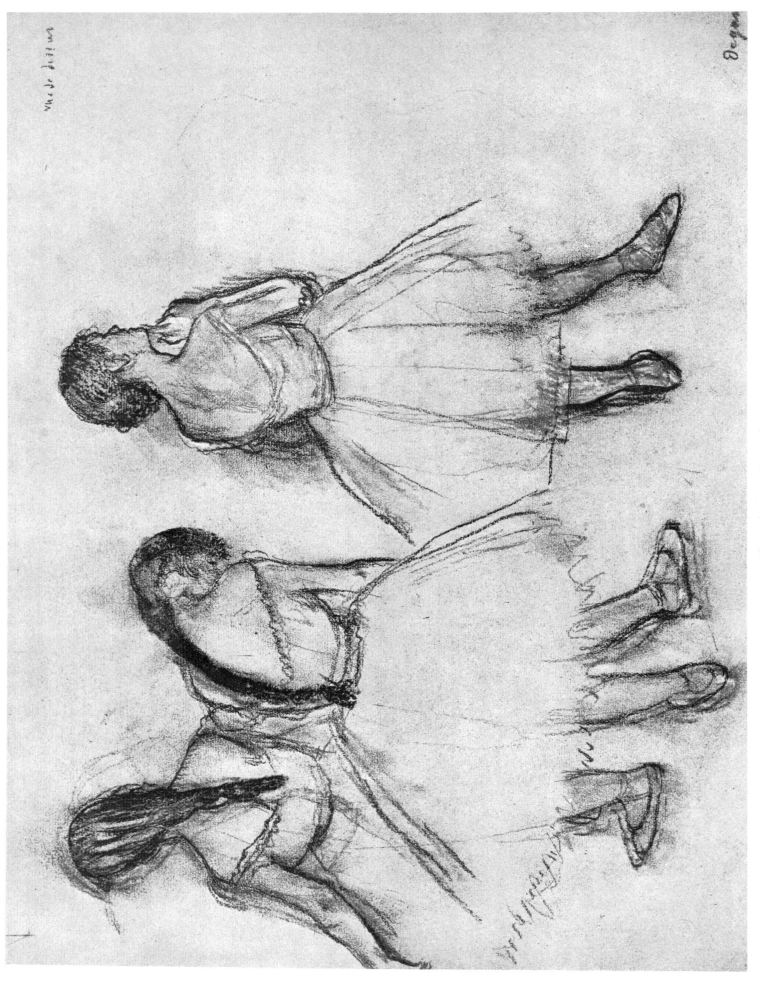

82. Three dancers. Ca. 1885–88.

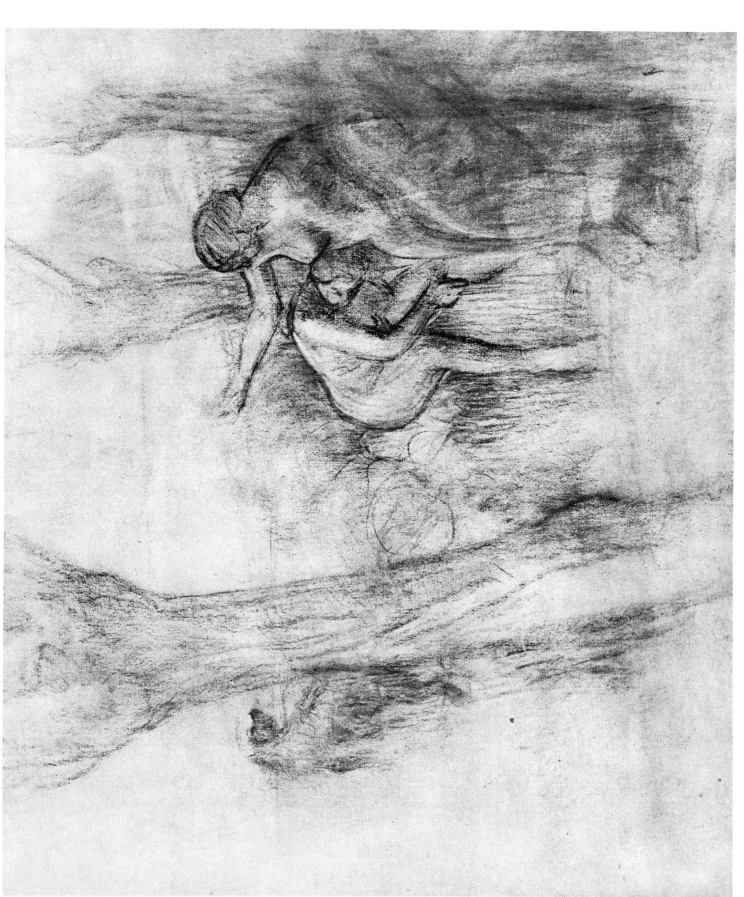

83. Three nude women under trees after bathing. Ca. 1885–90.

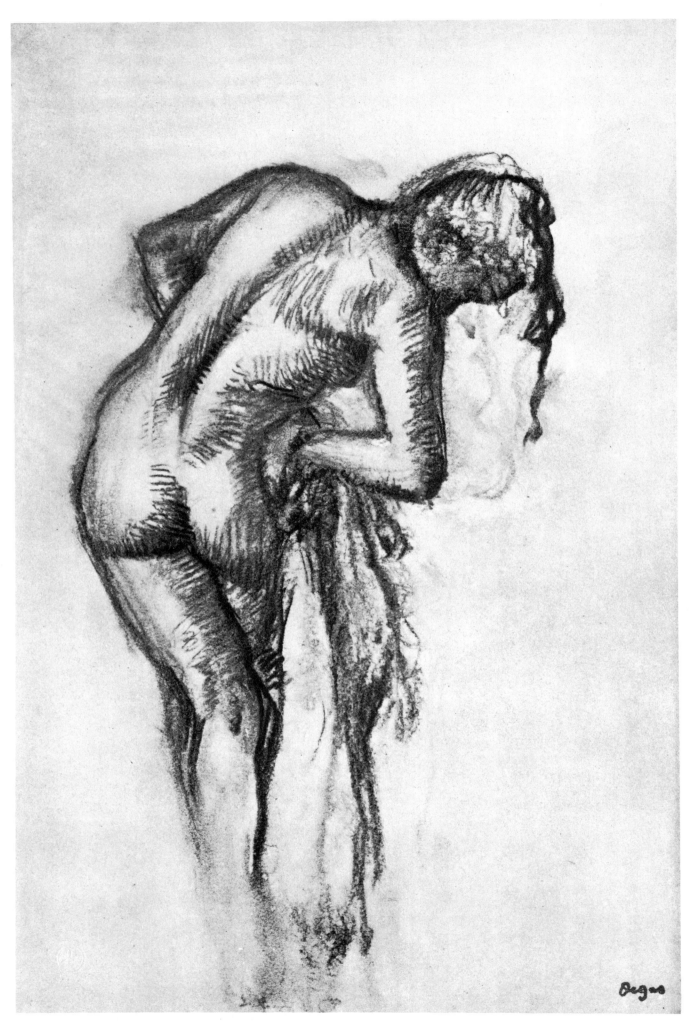

84. Woman drying herself after a bath. Ca. 1885–90.

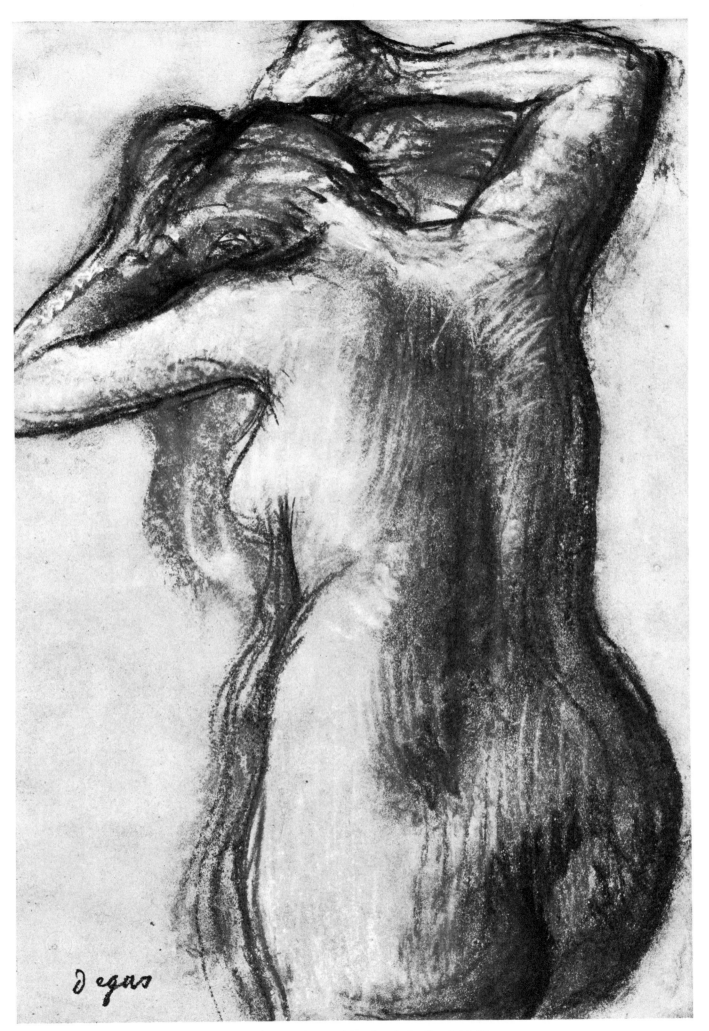

85.  Nude woman combing her hair. Ca. 1889–90.

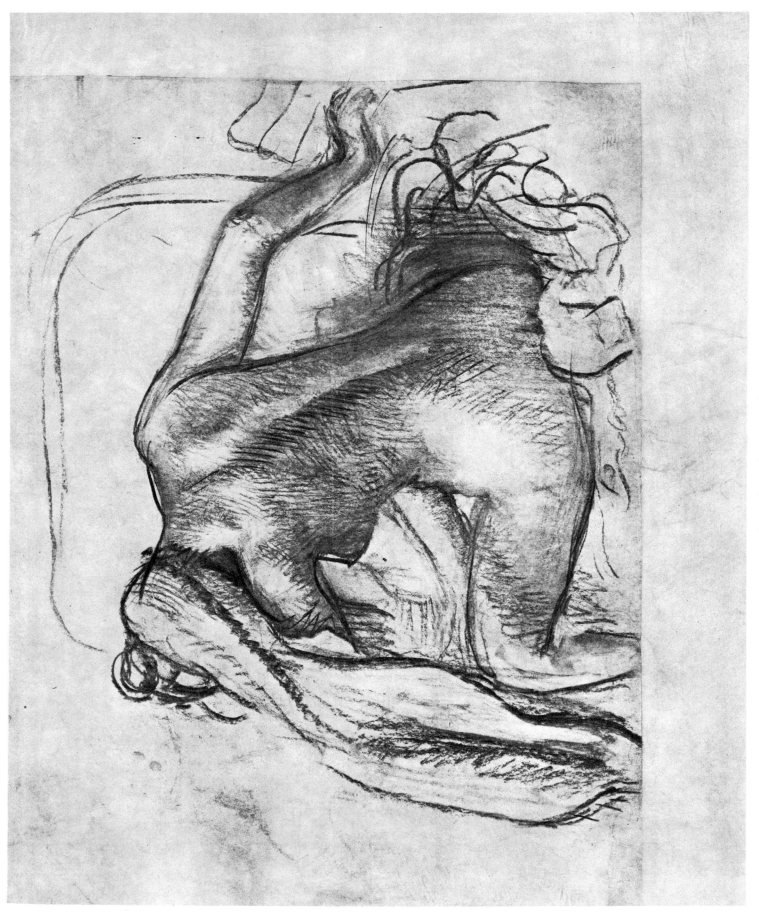

86. Woman drying herself after a bath. Ca. 1890–92.

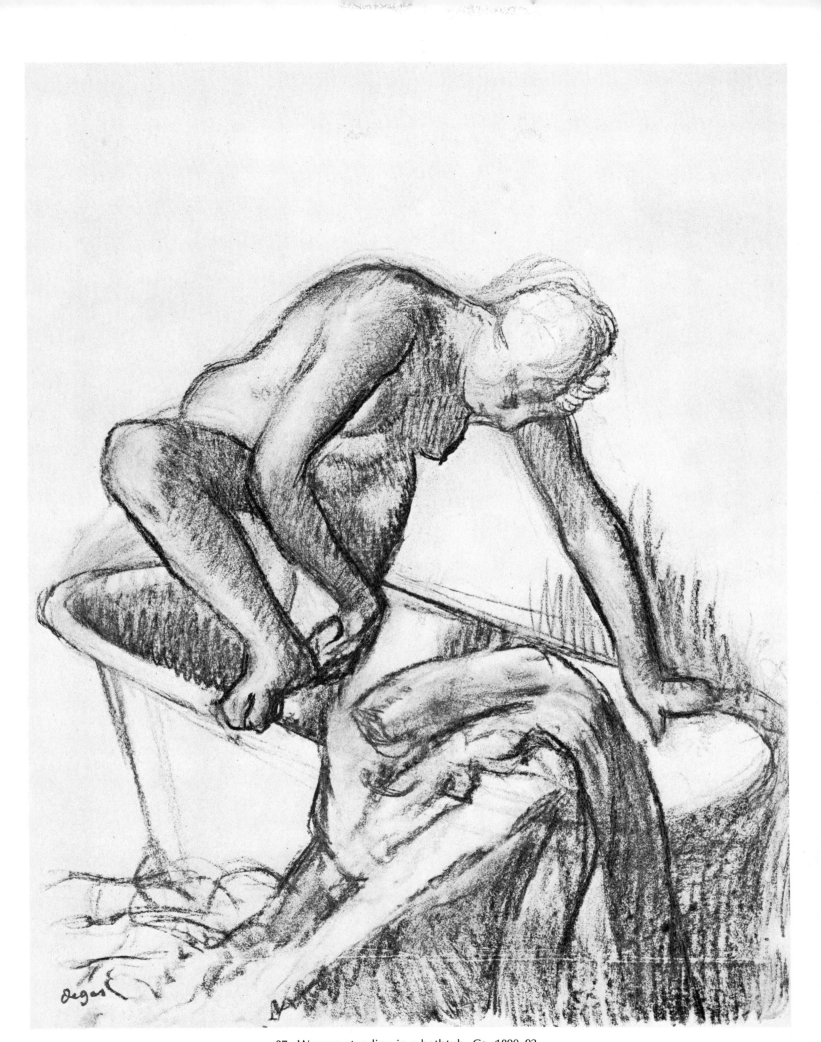

87. Woman standing in a bathtub. Ca. 1890–92.

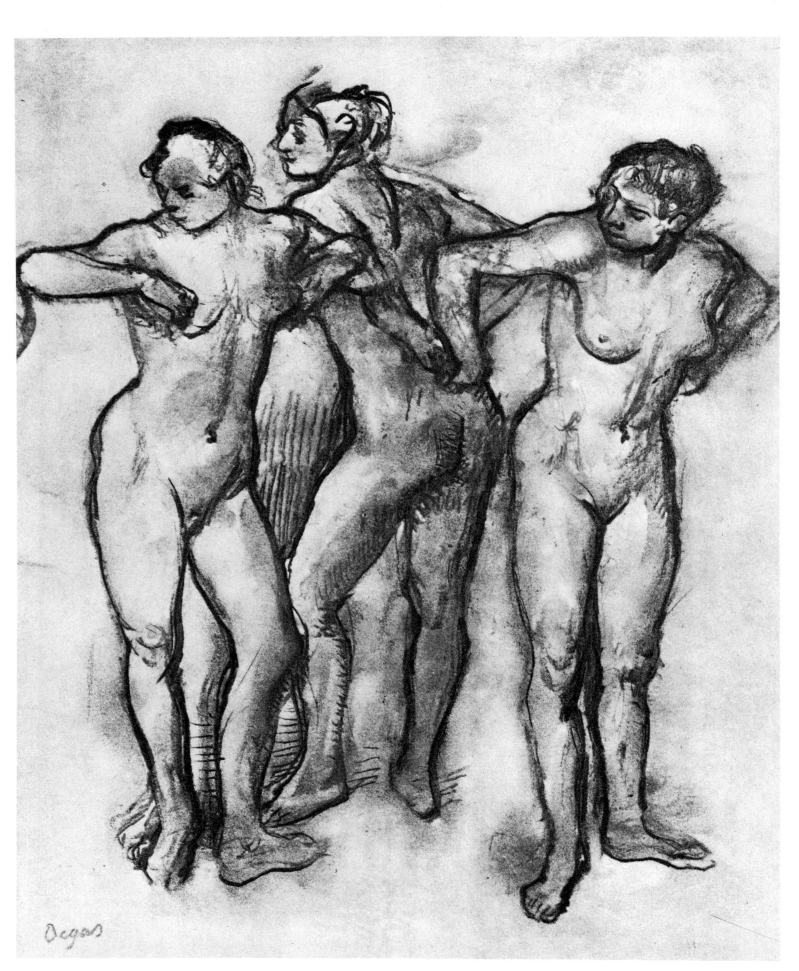

88. Three nude dancers. Ca. 1892–95.

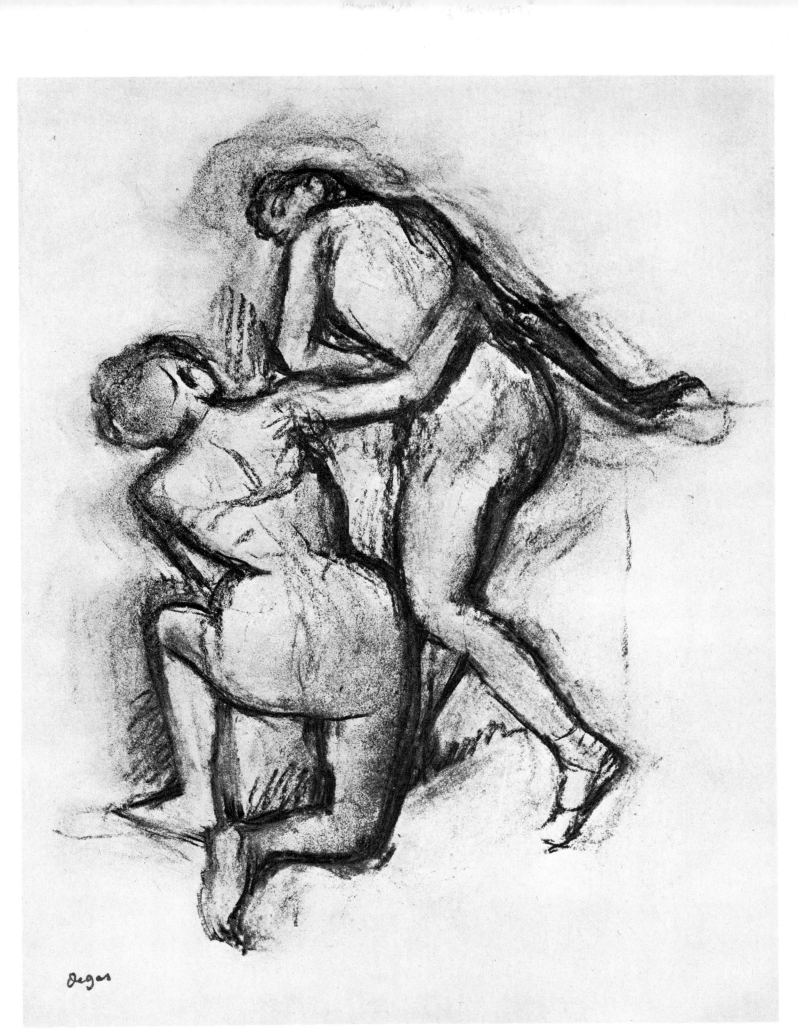

89. Two dancers in tights. Ca. 1892–95.

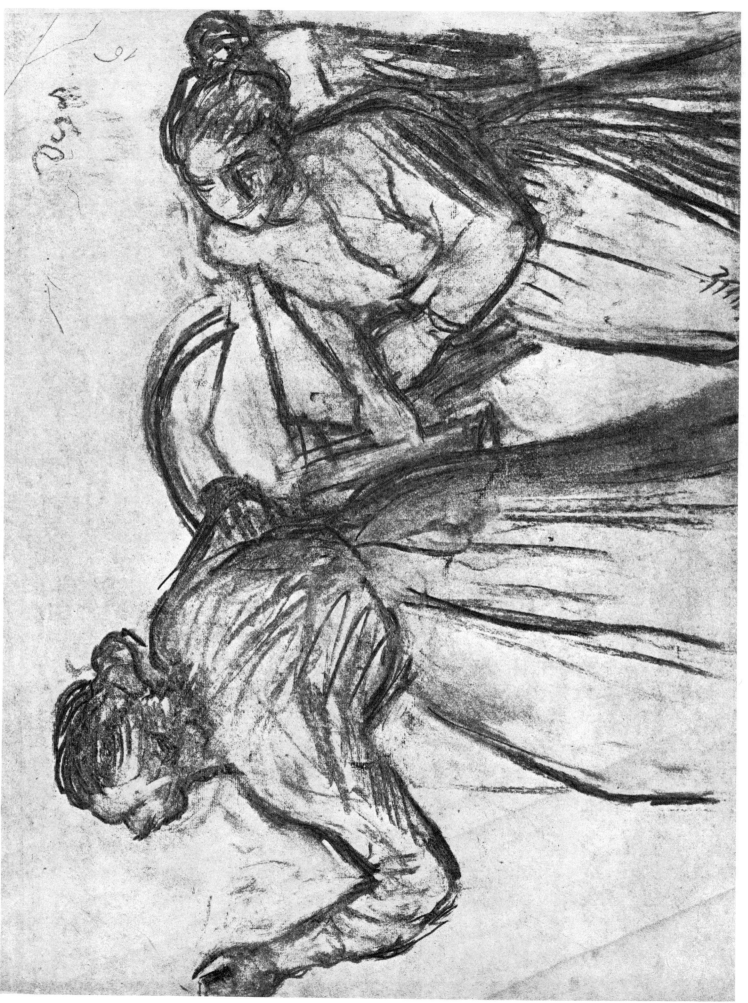

90. Two laundresses. Ca. 1892–95.

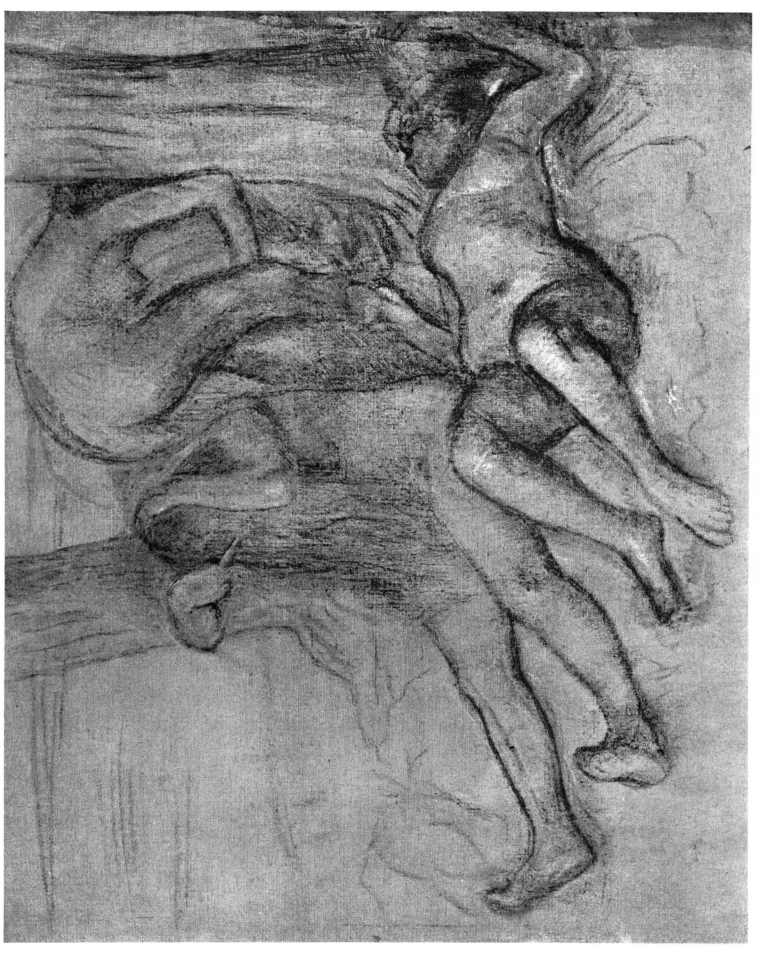

91. Bathers beneath willows. Ca. 1894.

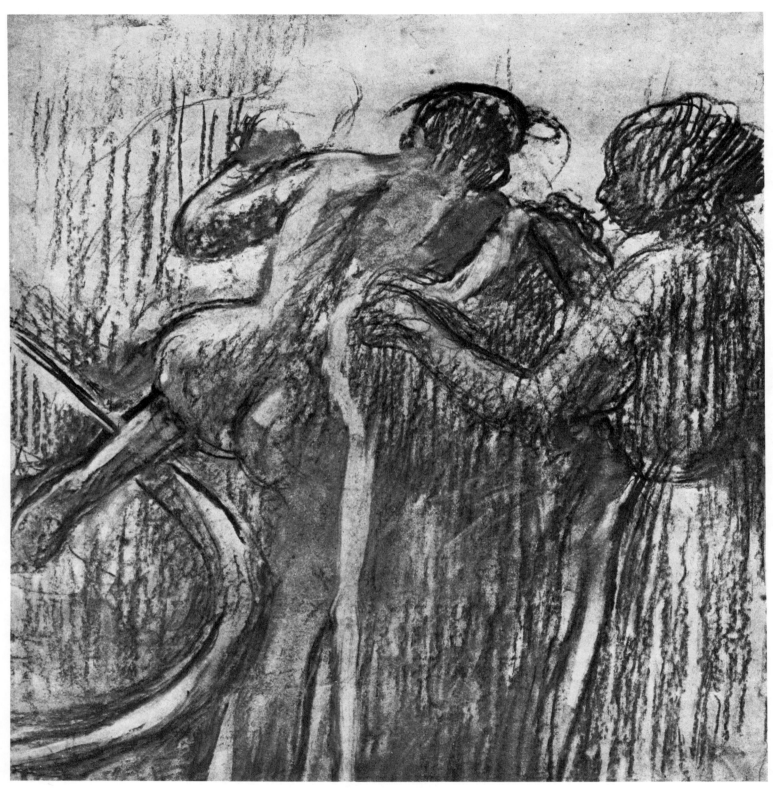

92. Woman stepping out of the tub. Ca. 1899–1902.